susan
POINT

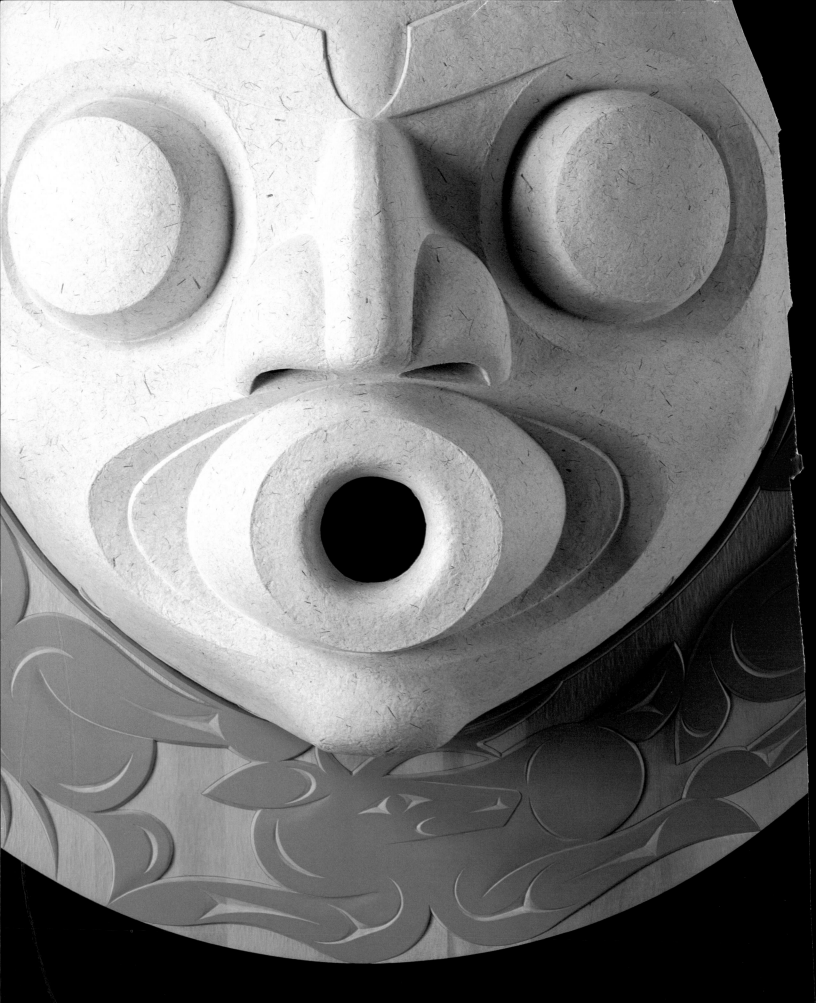

s u s a n
POINT

coast salish artist

Edited by Gary Wyatt

By Michael Kew
Peter Macnair
Vesta Giles
and Bill McLennan

Photographs by Kenji Nagai

Douglas & McIntyre
VANCOUVER/TORONTO

UNIVERSITY OF WASHINGTON PRESS
SEATTLE

Copyright © 2000 by Spirit Wrestler Gallery
Artworks copyright © 2000 by Susan A. Point

00 01 02 03 04 5 4 3 2 1

Douglas & McIntyre Ltd.
2323 Quebec Street, Suite 201
Vancouver, British Columbia V5T 4S7

CANADIAN CATALOGUING IN PUBLICATION DATA

Point, Susan A.
Susan Point, Coast Salish artist

Includes col. ill. of 45 works of art, with comments
by Susan Point.
Published to coincide with an exhibition held
Nov. 17, 2000, Vancouver, B.C.
Includes bibliographical references.
ISBN 1-55054-810-7

1. Point, Susan A. 2. Coast Salish art. I. Kew, J.E.
Michael. II. Wyatt, Gary R. III. Title.
N6549.P62A4 2000 709.2 C00-910970-6

Originated in Canada by Douglas & McIntyre and
published in the United States of America by the
University of Washington Press, PO Box 50096,
Seattle, WA 98145-5096

LIBRARY OF CONGRESS CATALOGING-IN-
PUBLICATION DATA

Susan Point: Coast Salish artist / edited by Gary
Wyatt; by Michael Kew … [et al.].
 p. cm.
 Includes bibliographical references.
 ISBN 0-295-98018-4 (alk. paper)
 1. Point, Susan A., 1952- 2. Coast Salish art.
3. Point, Susan A., 1952—Exhibitions. 4. Coast Salish
art—Exhibitions. I. Wyatt, Gary. II. Kew, Michael.
E99.S21.S86 2000
709'.2—DC21
 00-060706

Editing by Saeko Usukawa and Maureen Nicholson
Design by George Vaitkunas
Front cover: detail of *Point of Origin*, 2000,
red cedar, 7 feet in diameter × 6 inches.
Back cover: detail of *Sockeye Battle*, 2000, carved
glass, stainless steel, yellow cedar base, 36 inches in
diameter × 30 inches.
Printed and bound in Canada by
Hemlock Printers Ltd.
Printed on Luna Matte 100 lb. text from
Domtar, Eddy Specialty Papers, Vancouver,
manufacturer of high quality printing papers
Printed on acid-free paper

We gratefully acknowledge the financial support of
the Canada Council for the Arts, the British
Columbia Ministry of Tourism, Small Business and
Culture, and the Government of Canada through
the Book Publishing Industry Development
Program (BPIDP) for our publishing activities.

Contents

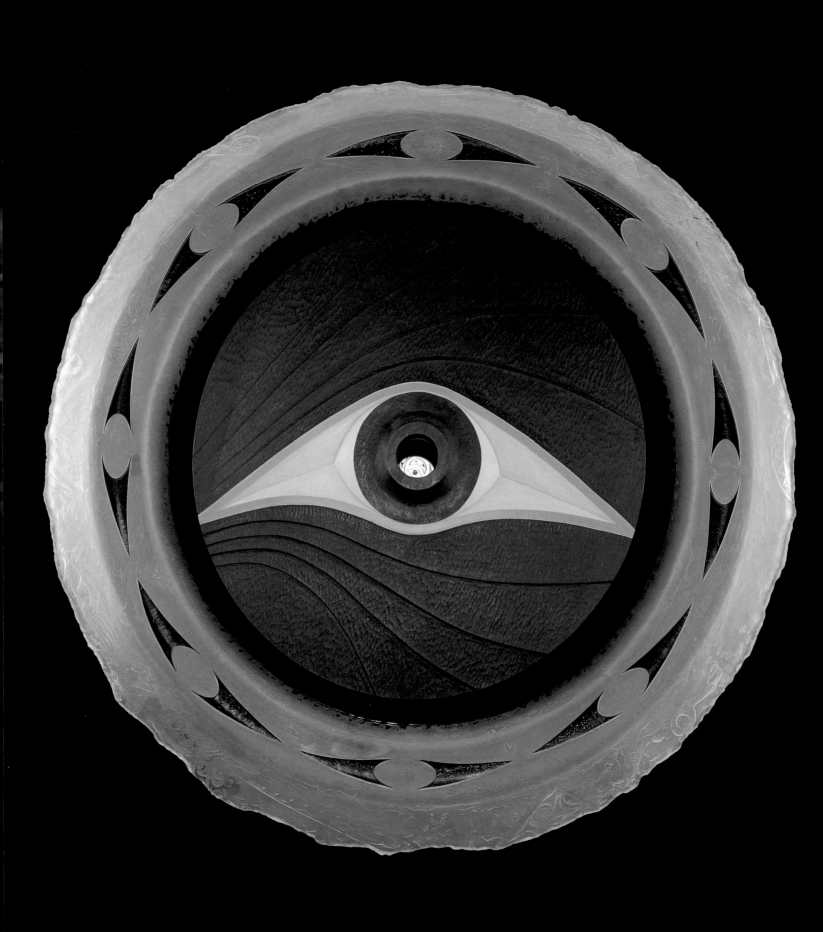

Preface

Writing the preface to this book is a daunting task, given the brilliance of the text that follows by Michael Kew, Peter Macnair, Vesta Giles and Bill McLennan. However, this gives me the freedom to talk about other aspects of Susan A. Point and her art, such as the level of creative energy and enthusiasm that she has brought to this ground-breaking project—and how excited we all became as the individual works started to take shape. It has been a pleasure to be part of the process and to work with Susan on this major exhibition and publication based on her art.

This book is a celebration of Susan Point's artistic career and offers a significant body of work created especially for an exhibition hosted by the Spirit Wrestler Gallery in Vancouver, as well as chronicling key works in her career to date. The exhibition itself represents the work of two years, during which time she also completed several monumental commissions. There are few circumstances in which an institution could offer an exhibition of this magnitude—more than forty works by a single artist, all of which are new works created for this exhibition. To my knowledge, such an event has not been attempted before.

Susan Point is an artist from Musqueam, one of several Coast Salish nations that originally inhabited the southern mainland of what is now British Columbia and that, despite the influence of extreme urbanization, remains a vibrant cultural and artistic community. Her work over nearly twenty years has led to her being considered to be among the most innovative Northwest Coast artists at work today.

When she began her career in the 1980s, very few Coast Salish artists were producing definitive Salish works. Traditional Coast Salish art, at its core, had a deeply private nature, a characteristic that continues to this day despite the increasing recognition and awareness of their artists. In the early days of the resurgence of Northwest Coast art, in the late 1960s through to the early 1980s, many Coast Salish artists chose to work in the styles of the more northern nations or stopped making art, partly because there were only a select few forms that were traditionally associated with Salish art, a fact that offered a limited market potential. In addition, the continued spiritual and private use of imagery and artworks led to restrictions from inside the culture on images and works that could be made for sale.

Raven's Eye, 1998
yellow cedar, carved and kiln-cast
glass, mirror, acrylic paint
38 inches in diameter
Private collection
Photo: Kenji Nagai

At a very early stage in her career, Susan Point chose to work only in the Coast Salish style. She viewed the restrictions and limitations not as obstacles but as possibilities and challenges that she addressed with great energy and vision, though always with respect. She quickly became the focus for the growing interest in the Coast Salish art form, as well as the catalyst for giving shape to the potential it offers for the exploration of contemporary ideas and mediums.

Point began as a graphic artist and learned the two-dimensional design forms unique to the Salish. She received several early commissions for graphic designs, quickly followed by invitations to take part in several exhibitions that made her work known to a wider audience. Her innate

artistry and desire to innovate then led her to adapt Coast Salish designs to non-traditional mediums such as glass and bronze, resulting in great critical acclaim. This success is a testament to her discipline and patience in studying and learning about these mediums, as well as to her skill in applying her ideas to them.

A visionary who enjoys creating monumental works, Susan Point has the ability to think on an architectural scale while using many different materials. This has led to commissions that push the established boundaries of Northwest Coast art. Her ability to see the possibilities of the space and to present her proposals with the support of architectural drawings has helped immeasurably toward securing these commissions. As a result, she has now a major public presence in southern British Columbia and the city of Seattle in Washington. In recent years, she has completed three major works for Vancouver International Airport, three house posts for the University of British Columbia Museum of Anthropology, a sculpture for the new Victoria Convention Centre, and a sculpture and wall installation mural for Langara College in Vancouver. Many other commissions are underway, including works for the new Seattle Stadium and conference facility and various international sites.

Although Point has a strong work ethic and enjoys the solitude of the studio environment, she also understands the strengths of consulting with other artists and craftsmen who have expertise in other mediums or techniques and who can collectively contribute to realizing her concepts. She often commissions the casting of pieces for inlays as well as the construction of the elaborate mounts, braces and stands necessary for the display of particular pieces, freeing her to concentrate on designing and carving. The larger business duties, such as scheduling the commissions and exhibitions, and running the studio, are overseen by her husband, Jeff Cannell, allowing her to devote more attention to her art.

Susan Point has succeeded in overcoming many of the limits that exist within Northwest Coast art, such as the dominance of male artists, as well as going beyond the boundaries of Northwest Coast art by adopting Western art influences and exploring the use of non-traditional materials and colours. Moreover, several of the public and corporate commissions she has won were open competitions with no preconceived focus on aboriginal or Northwest Coast Native art.

Many of the current generation of artists credit the renowned Haida artist Freda Diesing— one of the few female carvers—as an important teacher and influence on their decision to pursue art. Now, Susan Point has become a prominent influence on the next generation of artists, especially women. In addition, her works often incorporate motifs related to female arts, such as symbols used in the Salish weaving produced by women and designs carved on traditional women's utensils. At the same time, the increase in ceremonial activity in recent years and the ensuing demand for traditional regalia has helped more women artists to gain notice for their work in traditional female arts such as weaving and basketry, particularly as the labels

between art and craft have long disappeared. The presence of Point in exhibitions, particularly those that feature the growing emergence of Native women artists, is a recognition and celebration of the resurgence of some almost lost traditional styles and techniques together with a contemporary approach—an exciting combination that will strongly influence the future direction of Northwest Coast art.

While constantly widening her artistic knowledge through study and apprenticeships, Susan Point has also been a teacher and has served on several boards, including that of the Emily Carr Institute of Art and Design in Vancouver. In the spring of 2000, she received an honorary Doctorate of Arts degree from the University of Victoria for her contributions to the art world.

The artistic theme for this exhibition was to be an exploration into the interaction between people and the environment, but as each piece developed organically, other issues also became important. The bentwood box titled *Celebration of Differences* both illustrates the issue of racial prejudice and celebrates the differences between people. One more personal symbol, the ladybug, which Point often uses in conjunction with the frog, came from the close observation of life in her garden and her questions about the ladybug's food and survival, and the natural enemies that define its life and position in the food chain. Her best-known form, the spindle whorl (traditionally a small wooden disk with a central hole, into which is inserted a spindle) used to spin the sheep and mountain goat wool used in Salish weaving, has been a constant image from her earliest works to those of today.

As did her ancestors, Susan Point lives at the mouth of the Fraser River. There, she sees many of the motifs in nature that inspired Salish artists of the past: frogs, birds, grasses, flowers, fishers (otter-like creatures), great sturgeons lying deep in the mud of the Fraser, and, in close proximity, killerwhales, bears and deer. She is a member of the Musqueam Band, and the word *musqueam* translates as "people of the grass," referring to the inhabitants of the grassy banks of the Fraser River, another constant theme in her work.

This exhibition and publication coincide with a time when there is a great deal of interest in and excitement about the work of Susan Point. She has received some of the most prestigious commissions awarded to any Canadian artist in recent years, and her strong artistic vision, her contemporary concerns tempered with respect for tradition, her ability to work in a variety of mediums, and her mastery of scale from jewellery to monumental works, have won her a large, diverse and devoted audience.

—Gary Wyatt

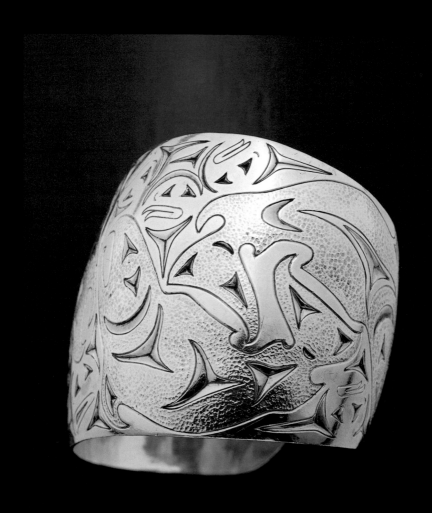

Acknowledgements

Before all else, Susan A. Point would like to express her deepest gratitude to her mother, Edna Grant-Point, and to her uncle, Dominic Point, who taught her the history of her people; and also to her ancestors, who left behind the rich legacy from which she draws her wealth of inspiration.

Together with Gary Wyatt of Spirit Wrestler Gallery, Susan Point would like to thank the following for their assistance in making this book and exhibition possible:

Susan's family, including Jeff Cannell, Kelly Cannell, Thomas Cannell, Brent Sparrow Jr. and Rhea Sparrow; and friends at Coast Salish Arts, for their dedication and contributions, including Ameen Gill, David Macdougall, Mark Mathison, Dindo Rieta, James Simon, Denise Wilson and Ron Denessen.

The artists and artisans who contributed to the realization of various works, including Eric Bourquin, Peter Braune, Nicole Dextra, Steve Fong, Peter Grant, Tom Hunt and Ross Hunt, Kip Jones and Bill Lalonde, David Montpetit and Farid Mousavi, Krista Point, Rosa Quintana and Mike Edwards, Larry Rosso, Yves Trudeau, Robert Keillor, Lane Campbell, Chuck Wright and a special thank you to Susan's friend, artist John Livingston, for his valued support.

The late Bud Mintz, for his encouragement and critiques, and in gratitude for his passion and selfless dedication to the indigenous art of the Northwest Coast.

The Spirit Wrestler Gallery would also like to thank the following for their contribution to mounting this important exhibition: Paul Lafontaine, Paul Gingras, Steven Bobb, Paul Slipper and Johnny Lavell.

Kenji Nagai, the principal photographer of new works for this project, as well as Bob Matheson, Jeff Cannell, Glen Laufer, the University of British Columbia Museum of Anthropology and the Royal British Columbia Museum.

Scott McIntyre of Douglas & McIntyre, for believing in this project; Saeko Usukawa and Maureen Nicholson for editing; and George Vaitkunas for designing the book. The writers, Michael Kew, Peter Macnair, Vesta Giles and Bill McLennan, for their words of insight and appreciation.

The staff of the Waterfront Hotel, the exhibition's venue, including Karen Van Schie, director of operations; Matthew Scott, chief concierge; Barbara Hicks, director of sales and marketing; Jill Killeen, director of public relations.

The staff of the Spirit Wrestler Gallery, for their hard work and determination on behalf of Susan's vision: Derek Norton, Nigel Reading, Colin Choi, Lindsay Butters and Minta Chan. And the gallery family—Marianne Otterstrom, Donna Alstad, Judy Nakashima, Christine Huang and the children, for their support.

Bracelet, 1991
silver
2 × 6 inches
Private collection of
Maxine Matilpi
Photo: Kenji Nagai

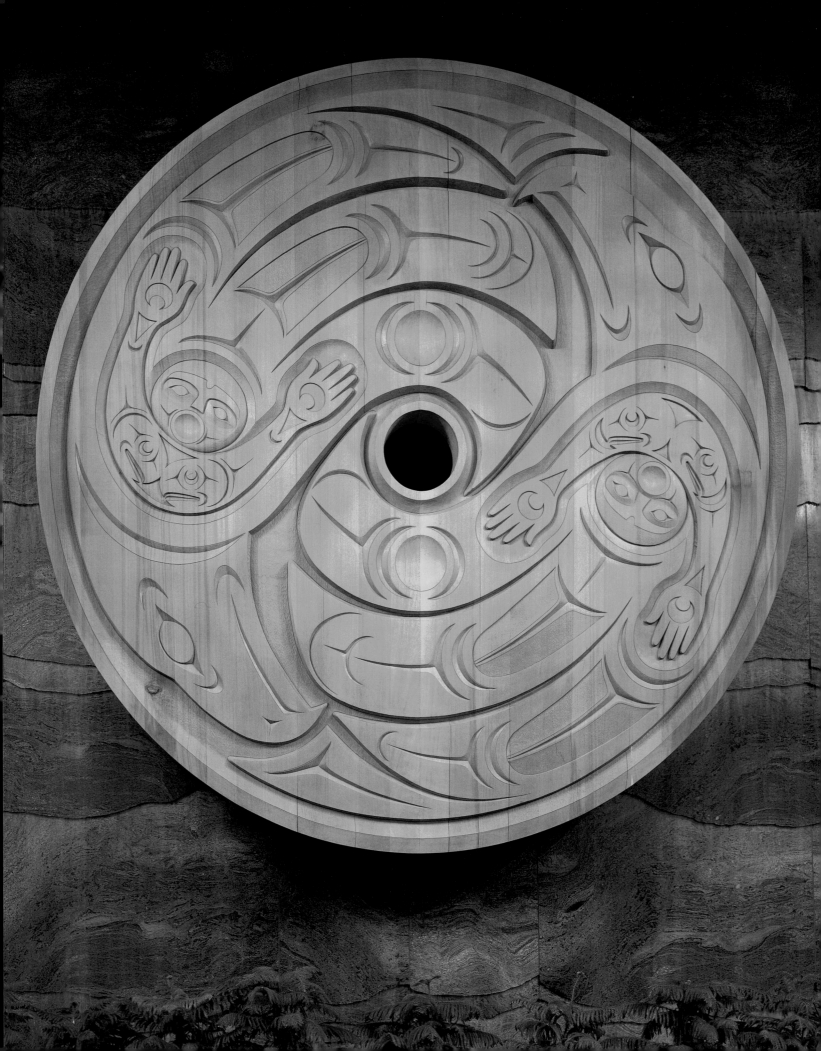

Traditional Coast Salish Art

In asking me to introduce the subject of traditional Coast Salish art, Susan A. Point is following a long established practice of Musqueam people. When something of importance about their family history needs to be said, they engage the services of a "speaker"—someone who will speak for them. I am pleased to be asked to fill this role, and although I speak with the voice of a teacher and an anthropologist, which I have been for most of my life, I have tried to temper that voice with an understanding of Susan Point's people and her family that comes from personal association.

Susan Point (E'ixwe'tiye) is a daughter of Edna Point (née Grant), a first cousin of my late wife, Della Kew (née Charles), and I am therefore Susan's "uncle," to use the English term that younger Musqueam people of Susan's age commonly use instead of the Hunqemi'nem term. Hunqemi'nem is my rendering of the Musqueam way of pronouncing their name for their own language. The word is variously pronounced in the several dialects of the language. Hereafter, I use the common English spelling, which is Halkomelem.

Although I have a degree in anthropology, my education and knowledge of anthropology really began outside the classroom and library, when I married Della in 1955 and slowly became one of the in-married members of Musqueam. For my understanding of their way of life, I am immeasurably indebted to my late wife and to her many kin, my "in-laws," and to all the people from Musqueam and their interconnected villages who have so kindly shared with me their experience and knowledge.

Halkomelem is one of many languages of British Columbia and Washington that belong to the Salishan linguistic family. Halkomelem is one of the largest Salishan languages in terms of numbers of speakers, and it is the language of the Sto:lo people of the Fraser River from Musqueam to Yale, as well as the language of the people whose homeland stretched from Nanoose Bay to Mill Bay on Vancouver Island. Speakers of Halkomelem are situated in the midst of a larger group of other Salishan languages, including Squamish, Sechelt, Comox and Lushootseed (Thompson and Kinkade 1990, 33-39). Although each of these other languages is distinct and unintelligible to the others, all Coast Salish peoples share many basic elements of culture, kinship systems, social organization, religious beliefs, technology and, finally, their art.

Originally, Coast Salish people enjoyed access to lands bountifully stocked with animals and birds. They also harvested a great variety of indigenous berries, edible greens, bulbs and roots. But the mainstay of their life was fish, particularly salmon. Living at the mouth of the Fraser River, the Musqueam had direct access to the five species of Pacific salmon as they arrived in their multiple successive runs throughout the year, on their way to upriver spawning grounds. Next in importance to salmon were the huge sturgeon, and then the diminutive eulachon. All of these still appear in their waters but now in sadly diminished numbers.

Flight, 1994
red cedar
16 feet in diameter
Commissioned by the Vancouver
International Airport Authority
and installed in the International
Arrivals Terminal, Vancouver
International Airport
Photo: Bob Matheson

Although the lifeways of Salishan peoples had much in common, particulars of their local environments varied widely. Sto:lo had access to mountain goat ranges, but no clam or mussel beds to harvest. Vancouver Island people had bounteous stocks of shellfish and herring, but no mountain goats lived there. Such local differences in the occurrence and abundance of foods and raw materials were offset by extensive trade and ceremonial gift-giving. Travel between villages and across the Strait of Georgia was facilitated by the use of large cedar canoes. Marriages were sought between people of different villages, and these ties of kinship cemented alliances and trade.

In 1827, when the first Hudson's Bay Company fur-trading post was established at Fort Langley in Salish territory, the traders witnessed an ancient pattern of annual movement as flotillas of canoes, many fastened in pairs by cross-planks to create catamarans and piled with household goods and people, busily plied the Fraser River to visit kinfolk or to trade. Even then, before European settlement, the river was a cosmopolitan centre of transport and trade (Maclachlan 1998, 34). But when the early traders observed this populous area with its thriving indigenous economy, diseases introduced by European visitors—particularly smallpox—had ravaged these Salishan populations for some fifty years (Boyd 1990, 1994) until they were merely a shadow of the bounty and abundance of earlier times. It is from that richness of place and complexity of ancient cultural tradition that Susan Point's art draws its vitality.

"Art" as an explicit form of expression and "artist" as a recognized profession were not part of traditional Coast Salish life. But perfection of craft, skill in performance, admiration of pleasing product—these surely were part of everyday experience long ago, just as they are today. The many peoples of the Northwest Coast, from southwestern Alaska to northern California, shared basic patterns of life: dependence upon fishing, highly developed uses of wood and wood fibres for housing and material objects, stratified societies, localized ownership of lands and resources, elaborate rites of wealth display and gift exchange. Within these cultures, artistic and aesthetic appreciation were shaped and developed to create distinct regional styles of art, and these endure in both traditional and modern modes of expression.

Music, dance, storytelling and oratory are often overlooked as forms of art, but among the Coast Salish they might best be called the ritual arts. They have always been important and still are a vital part of community life—although it is not as "art" that they are recognized and given note. Halkomelem-speaking communities sit like small islands within their larger tribal territories, now occupied and populated mainly by outsiders, yet they still maintain their own ways of life. Their communities centre on supportive institutions that have survived unbroken from ancient times (Kew 1970, 1990), in which music, dance and oratory thrive. These ritual arts play a central part in religious and ceremonial activities—in keeping to ancient ideas about wellness, and in maintaining family history and social standing. These activities are confined to Salish

communities where they are protected from the outside world and secured within the control of the practitioners. By and large, these Coast Salish ritual arts are not for sale, and photographs and sound recordings of them are strictly disallowed. The sacred music and dances are not performed on the public stage; they retain their meaning and continue to be vehicles of instruction through which people learn their own history and their place in their community. For many, these ceremonies are the means of personal fulfillment, focussing and giving strength to individual lives. Growing up within a family and society where such activities are part of daily life has shaped and strengthened Susan Point.

One of the products of everyday Salish life that gained early recognition for excellence and beauty is woven textiles. In 1808, the North West Company explorer Simon Fraser described Sto:lo robes as having "stripes of different colours crossing at right angles. Resembling at a distance Highland plaid." He noted that "they were equally as good as those found in Canada" (Lamb 1960, 99, 101). Made on large two-bar, roller looms, from homespun mountain goat and dog wool, these heavy blankets were woven by women throughout the Coast Salish area. They are now, as in the past, items of wealth to be worn on ceremonial occasions; respected leaders may be wrapped in them after death and wear them to their graves. Salish blankets have enjoyed a recent revival of interest and production, and they are now much prized *objets d'art* (Gustafson 1980).

Much less well known and often not recognized as works of art are basketry, matting and cordage. Like many other traditional products, these have all but passed from Coast Salish life with the introduction of easily obtainable manufactured replacements. For a period of time late in the nineteenth and early twentieth centuries, the making of cedar-root coiled baskets for sale flourished, and museum collections today attest to the skill and artistry of the women who made them. Susan Point's mother, Edna Grant, was one of the last Musqueam women who knew how to make such baskets, as well as the sewn cattail mats that at one time lined the inside walls of Musqueam family houses. From Edna Grant and others of her generation who provided vital links with past knowledge, these skills have been passed on to younger people.

While many products like factory-made cloth and cordage were replacing indigenous equipment over the last century, ancient Salish skills with cordage and textiles found another medium in the introduced technique of knitting. For several generations, the heavy "Cowichan" sweaters knitted from homespun sheep wool have been sought for their warmth, durability and decorative design. They have been official gifts to princes, presidents and other visiting dignitaries as British Columbia "native handicrafts." But the knitters possess a great store of knowledge about wool preparation, blending of fibres for colour, mode of making sweaters with integral collars and sleeves, and critical ideas and refinements of design. Their knitting is more than a handicraft and is rightfully linked with other textile arts.

Susan Point is not a textile artist, but she was raised in a household and community where such work and artistry are valued. They have also influenced her work as a painter, printmaker and sculptor.

ANCIENT ROOTS OF SALISH SCULPTURE

Archaeological research in Salish territory has unveiled abundant evidence of the sculptural arts, developed to high levels of sophistication in technique and style. The soapstone sculptures associated with the seated human figure bowl complex (Duff 1956) alone would place the Salish within a great artistic tradition. These ancient works are from a period 1,500 to 2,500 years ago, known as the Marpole phase, named after a site on Musqueam lands (Borden n.d., 131-32). Numerous small bone and antler sculptures with early dates also attest to the richness of Salish sculptural tradition, whose elements have endured into the modern era to be revealed in historically collected art objects.

What the archaeological record cannot show directly is the wealth of sculpture in wood from those earlier times. A few pieces, fortunately preserved by being buried in mud or submerged in waterlogged depths of low-lying midden deposits, have survived to serve as a glimpse of the possibilities.

Salish territory was home to all the Northwest Coast woods, many with special qualities suited to particular needs: durable red cedar for planks, canoes and boxes; pliable yellow cedar and maple for paddles; Douglas fir for harpoon shafts and canoe poles; maple and alder for spoons and bowls; yew for bows, wedges and clubs. Other materials used for tools, and sometimes sculpture, include soft soapstone and various other hard close-grained rocks, which were shaped by pecking and battering with other stones. Antler from deer and elk, horn from mountain sheep and mountain goat, and bone of various kinds complete the list of essential materials.

Ancient aboriginal tools with stone or beaver-tooth cutting blades were entirely adequate for making exquisite miniature sculpture as well as canoes and monumental works in wood. A few simple iron tools reached the Salish and other Northwest Coast people through inter-tribal exchange long before European fur traders came to the coast. But fur traders introduced to eager hands such iron and steel tools as axes, chisels, saws and knives. These made easier or more efficient the routine tasks of men and women, but some traditional tools—especially wedges, hammers and adzes—were so efficient that they are still in use. In recent years, Northwest Coast artists, like their forebears, have added new tools: chainsaws and a wide range of electrical power tools. They have also, with Susan Point among the first, experimented with new materials like glass, bronze and various synthetic compounds. In this way, the age-old process of adaptation is ongoing.

Wood, however, has been from earliest times until the present the predominant medium for Coast Salish sculpture, both large and small. Again, the earliest written record of these among Halkomelem speakers comes from the journal of Simon Fraser, who in 1808 described their tombs: "Upon the boards and posts are carved beasts and birds." Farther down the river, Fraser entered a large house, 195 × 18 metres (640 by 60 feet), with a "Chief's" apartment in which "the posts or pillars are nearly 3 feet [in] diameter at the base, and diminish gradually to the top. In one of these posts is an oval opening answering the purpose of a door . . . Above, on the outside, are carved a human figure large as life, and there are other figures in imitation of beasts and birds" (Lamb 1960, 98, 103-4).

A few examples of large sculptures in these traditional styles have been preserved, and both carved house posts and tombs are on display at the University of British Columbia Museum of Anthropology in Vancouver. Some are sculptured fully in the round, with figures of humans and animals depicted in realistic bodily proportions. Others, such as those on house posts, were often created in high relief, with excess wood removed to present the animal or human form lifted fully but attached upon a solid and structurally supportive background. House posts may depict mythical creatures associated with family history, notably ancestors, or events that displayed the spirit powers of ancestors or the magical privileges of the family. They proclaimed to occupants and guests alike the long history, wealth and high status of the family. Such fully modelled, three-dimensional sculpture and high relief is also rendered on the few remaining examples of tomb sculpture, which may feature ancestor figures and their spirit powers.

Sometimes both high relief and low relief are combined on the same piece to provide a pleasing variety. Relief sculpture enabled artists to achieve dynamic and realistic associations of figures: animals chasing one another, birds being held by a human, people and animals confronting one another. The subjects include birds and mammals, generally of unspecific identity. Human figures and faces predominate. The figures have distinctive features, are naturalistic in proportion and are sometimes shown in an activity or a pose. This emphasis on realism, in the case of human effigy figures, extended to rendering buttons and other details of clothing. Human faces bear the stamp of a generalized Northwest Coast style, but they have their own unique features. Eyebrows are prominent, arched and often join above or are attached to a long thin nose, which has tiny pinched nostrils. Eyes, usually oval and proportionately smaller than in other Northwest Coast styles, are surrounded by clearly marked eyelid forms.

On a smaller scale, wooden sculptures are rendered on a variety of tools and implements—both sacred or ritual objects like masks and rattle handles, as well as working tools like adze handles, loom posts and fish clubs. The small wooden implement known as a mat-creaser deserves special mention. It is a woman's tool for crimping the fibres of cattail and tule reeds that are being sewn together to form large mats. The functional component of the tool is a flat, hand-sized piece of

wood, convex in outline, with a V-shaped groove cut into the convex part; a portion serves as the handle with which to hold it. In use, the grooved part is pressed down upon the plant fibres while they lie skewered by a large triangular cross-sectioned wooden needle, to crimp the fibres before pulling the needle through, leaving the cord cross-fibre. Aside from its few essential functional elements, the implement has no standard form. Indeed, mat-creasers in museum collections display a wonderful diversity and ingenuity of form, from realistic little ducks to stylized animal and bird forms to elegant non-representational forms, as if the artists were amusing themselves.

Some sculptured figures were painted red over the whole surface, without attention to detail, or rarely, as an embellishment of engraved surfaces. Red paint made from baked clay and black from charred vegetable fibres were widely used in sacred ritual, but the use of paint on wood as a decorative technique seems not to have been common nor to have been used to depict representative figures.

Much more frequently used for decorative purposes was the technique of engraving. Line engraving is the simplest mode and consists merely of cutting a line or lines that constitute or define a two-dimensional form. This is probably one of the oldest means of decoration and is applied to a wide variety of objects. It is also the technique employed to make the images called petroglyphs that are cut into sandstone and occur throughout the southern Strait of Georgia region (Hill and Hill 1974).

Block engraving is a more complex mode of executing designs (Kew 1980). It resembles the technique used for making woodblocks or linocuts to be inked and printed. The design forms are conveyed by positive surfaces, which are delineated by cutting around their perimeters and outlining them with a narrow space or by totally removing the surrounding surface. The interior of the positive form may then be embellished by various lines or cuts to provide details. Although the engraved design is usually carried on a single surface, it may extend over the whole design field or merely over a portion. In other applications, surfaces are superimposed on one another to achieve depth or a third dimension of form. Block engraving was applied to some large wood surfaces as well as smaller implements and was especially favoured for the decoration of horn from mountain sheep and goats.

Subjects represented in engraving are few in number and appear to be generic rather than specific in identity. For example, birds as a class are represented, rather than eagles, ravens or other particular species. Human figures are common subjects, but they are infrequently engraved, being more often shown in low relief even on otherwise totally engraved pieces.

One significant item decorated by engraving is the spindle whorl, which was used for spinning the heavy mountain goat wool into yarn. Many spindle whorls are outstanding objects of art, with complete integrated compositions of engraved animal and human figures. Some designs

represent personal spirit powers or are representations of guardian spirits; other themes or figures appear to have been derived from mythology.

The technique of block engraving is ideally suited to transference for use in silkscreen printing. This "natural" character of engraved Salish designs has facilitated the creation of serigraphs by Susan Point and other contemporary artists.

Meaning in Coast Salish Art

The study of Salish sculpture and engraving poses questions about their meaning. Certainly, much art has always been ambiguous or inexplicit in meaning, whether it consists of images caught with a camera or images depicted from a dream. Any work of art has a meaning to the maker and a meaning to the viewer. The two may agree, but they are not always identical, and they are not prescribed. There is an edge of uncertainty or mystery about the meaning of a work of art, even within a culture. The possibility of misunderstandings is far greater still when artist and viewer are from different cultures.

Written records of traditional Salish life provide little help in understanding the art. Scant attention was given to the art by outsiders, and the meaning of objects we now regard as art was often not considered a proper topic for discussion by the Salish. It is fair to say that all visual images, in their eyes, contain an implicit reference or a potential connection to the sources of power revealed to an individual in dreams and visions. The Musqueam, like other Coast Salish, hold dreams and visions to be conveyors of power that are fundamental to a full life and capable of imparting extraordinary benefits, yet always dangerous. Thus, for them, visual images have a potential connection to power and danger: to discuss images openly, to treat them casually, to reveal too freely what is known of their origin, is to court danger. Works of graphic and sculptural art were and are treated circumspectly by the Coast Salish, and so they are never easy subjects for ethnographic inquiry.

This sacred and private character of art objects among the Coast Salish, in contrast to a more secular and public place for art among the northern Northwest Coast people, underlies both the differences in those arts and the way in which anthropologists have interpreted them. The Coast Salish probably produced less material art, in quantitative terms, than their neighbours to the north. In addition, the Salish were often less willing to part with objects and much less willing to talk about them. Nor did they adapt their own images and modes of design to the production of curios for sale to outsiders. As a result, very little Coast Salish art was acquired by traders and collectors to stock the shelves of museums. What was collected was overshadowed by the abundant and spectacular art of the northern and central areas of the Northwest Coast, whose forms and styles have mistakenly come to represent the art of the coast as a whole.

The roots of this Coast Salish ambivalence about images—the fact that they are made, used and valued, yet at the same time treated circumspectly—are to be found in their religious beliefs. Humans are considered to be apart from yet dependent upon non-human powers that are mysterious and never completely knowable. These powers may be associated with particular life forms—animals, birds, fish and so on—or natural phenomena and mysterious beings associated with particular places. Because of their influence over human life and, in turn, human dependency upon them, such powers are the foci of ritual prayers or annual events of thanks and renewal. The widespread "first salmon" ceremony of propitiation and thanksgiving is an example of such an event.

These powers can also visit or associate with individuals, providing great benefits like strength, health and good fortune; but they can also bring illness and eventual death. Such dire consequences are guarded against and avoided by learning to understand the teachings and knowledge given by the powers to a human in the form of dreams or visions. Specialists who are learned in understanding and aiding individuals to manage such power relationships are called upon to assist the ill and to instruct the young.

While such power relationships may come unsought by individuals, such relationships, being a source of strength and therefore valued, are also purposefully sought. This is done in so-called spirit-quests, in which a person fasts, bathes frequently in streams or forest pools, and departs from other humans into mountainous and forested places—in short, cleanses and disassociates the self from humans and human conditions. With success and perseverance, an individual may undergo a religious experience and receive, in a dream or vision, instruction from a spirit power (Jenness 1955, 48-49) in the form of a song and the movements of dance. These are together an individual's *syewen*; that is to say, the manifestation of "spirit powers."

Details of dreams and visions are entirely private and under ordinary conditions are never talked about or revealed to others. To do so is to violate the power association and to endanger the human partner. Some graphic depictions of such personal powers were sometimes placed upon objects decorating tombs or on personal implements. But like other elements of power experiences, their meaning was not made explicit. Because of the potency of such images and the danger inherent in using them in an offensive or careless manner, images were treated circumspectly and not talked about freely. This may well have curtailed the production of Salish objects of art and would explain the unwillingness of owners to sell decorated objects to collectors or to discuss the meaning of images (Suttles 1984, 131-33).

This reticence is especially evident in a group of sacred objects used in ritual acts of cleansing and blessing. Some of these, which were collected by early museum buyers and valued for their artistic merit, continue to hold significance and to be made anew for use in contemporary ritual. Among these are rattles, sometimes made of mountain sheep horn, sometimes wood or

copper, and fringed with mountain goat wool. The globular hollow portions of these rattles are often decorated with block engraved designs, and the handles with sculptured human or animal forms. These rattles, used to accompany special songs, are private property held by families. In keeping with the Coast Salish practice of bilineal inheritance, they are passed down through both the male and the female lines and may be owned by individuals of either gender. The meaning or significance of images on the rattles is, like the instruments themselves, private property, closely associated with the powers that conferred them upon the ancestors.

Another kind of such ritual objects are the masks, known as *swaixwe*, which are worn by men during the performance of ritual cleansing and blessing. Again, the masks, costumes, songs and ritual knowledge involved in the performance are family owned and highly valued. The masks and their performance are said to have originated long ago in the experiences of ancestors who were given the masks and knowledge of their use during a mysterious other-world experience or by an empowered visitor (Jenness 1955, 91-92).

In contrast to such ceremonial objects, the Salish had many ordinary or decorated articles for everyday use, such as spoons, bowls, mat-creasers, fish clubs, horn bracelets, basketry and the like. Most such everyday objects that are now in museums were collected before 1940. The rare horn bracelets, block engraved with what appear to be non-representative designs, were collected around the end of the eighteenth century, after which their creation and use were discontinued. Like many other objects that were simply decorative or technical, they probably were replaced by other easily acquired manufactured trade items. Similarly, the creation of sculptured house posts ceased by the beginning of the twentieth century as the practice of many families living together in large dwellings gradually ceased. Also, the use of family tombs adorned with sculptured images gave way to single graves in Christian cemeteries. The few museum specimens of monumental grave sculptures from the Coast Salish area date mainly from the period between 1890 and 1935.

Although Salish masks and rattles were collected for museums in the first part of the twentieth century, and some masks were even made for sale, the sacred value of such objects and their continuing use has led representatives of owning families to limit their acquisition by collectors and to secure the removal of the objects themselves from public display. Most Coast Salish artists will not replicate these objects for sale to people who do not have ownership rights, and they also will not use the images in public art. Thus, as Professor Wayne Suttles phrased it, there are still strong "constraints" upon the production of Salish art (Suttles 1984), and upon its public display as well. However, it would be entirely misleading to think that such constraints impose heavy limitations upon artists.

While observing sacred restrictions and maintaining respect for community values, Susan Point has applied old traditions of Salish design to new subjects, as well as experimenting successfully

with new materials. Thus, her work is not so much a break with tradition but rather a continuation of it. Indigenous art, like all art, is embedded in the social system from which it stems, and as the society changes, so must its art. If the cultural roots are strong and alive, the art will flourish and grow, creating new forms and meanings. While the Coast Salish have maintained their culture for the past two centuries of settlement by outsiders, they have also been a part of that impinging world, interacting selectively, giving much, but keeping themselves intact. Their traditional art will continue to meet their community needs under their direction and control, but it has also taken a new direction as a public statement and witness of their abiding presence. Susan Point has played a major role in this new wave of Salish art, using old designs and forms as inspiration to create new images with new meanings—prints for living room walls, friezes on public buildings, house posts in front of museums, or larger-than-life spindle whorls in airports. All these exciting works, in their combinations of traditional and new materials and images, attest to Susan Point's vision and stature as an artist. At the same time, her work proclaims the enduring presence of her people in their land.

REFERENCES

Borden, Charles E. n.d. Prehistoric Art of the Lower Fraser Region. In *Indian Art Traditions of the Northwest Coast*, ed. Roy Carlson. Burnaby: Archaeological Press, Simon Fraser University.

Boyd, Robert. 1990. Demographic History 1774-1874. In *Handbook of North American Indians.* Vol. 7, *Northwest Coast*, ed. Wayne Suttles, 135-49. Washington, D.C.: Smithsonian Institution Press.

—. 1994. Smallpox in the Pacific Northwest: The First Epidemics. *B.C. Studies*, 101:5-40.

Duff, Wilson. 1956. *Prehistoric Sculpture of the Fraser River and Gulf of Georgia.* Anthropology in British Columbia, No. 5. Victoria: Provincial Museum.

Gustafson, Paula. 1980. *Salish Weaving.* Vancouver/Toronto: Douglas & McIntyre; Seattle: University of Washington Press.

Hill, Beth, and Ray Hill. 1974. *Indian Petroglyphs of the Pacific Northwest.* Saanichton, B.C.: Hancock House.

Jenness, Diamond. 1955. *The Faith of a Coast Salish Indian.* Anthropology in British Columbia. Victoria: British Columbia Provincial Museum.

Kew, Michael. 1970. Coast Salish Ceremonial Life: Status and Identity in a Modern Village. Ph.D. diss., Department of Anthropology, University of Washington, Seattle.

—. 1980. *Sculpture and Engraving of the Central Coast Salish Indians.* Museum Note No. 9. Vancouver: University of British Columbia Museum of Anthropology.

—. 1990. Central and Southern Coast Salish Ceremonies Since 1900. In *Handbook of North American Indians.* Vol. 7, *Northwest Coast*, ed. Wayne Suttles, 476-81. Washington, D.C.: Smithsonian Institution Press.

Lamb, W. Kaye. 1960. *The Letters and Journals of Simon Fraser, 1806-1808.* Toronto: Macmillan Company of Canada.

Maclachlan, Morag, ed. 1998. *The Fort Langley Journals, 1827-1830.* Vancouver: University of British Columbia Press.

Suttles, Wayne. 1984. Productivity and Its Constraints: A Coast Salish Case. In *Coast Salish Essays*, ed. Wayne Suttles, 100-136. Vancouver: Talon Books, Vancouver. And in, n.d., *Indian Art Traditions of the Northwest Coast*, ed. Roy Carlson, 67-87. Burnaby, B.C.: Archaeological Press, Simon Fraser University.

Thompson, Laurence C., and M. Dale Kinkade. 1990. Languages. In *Handbook of North American Indians.* Vol. 7, *Northwest Coast*, ed. Wayne Suttles, 30-51. Washington, D.C.: Smithsonian Institution Press.

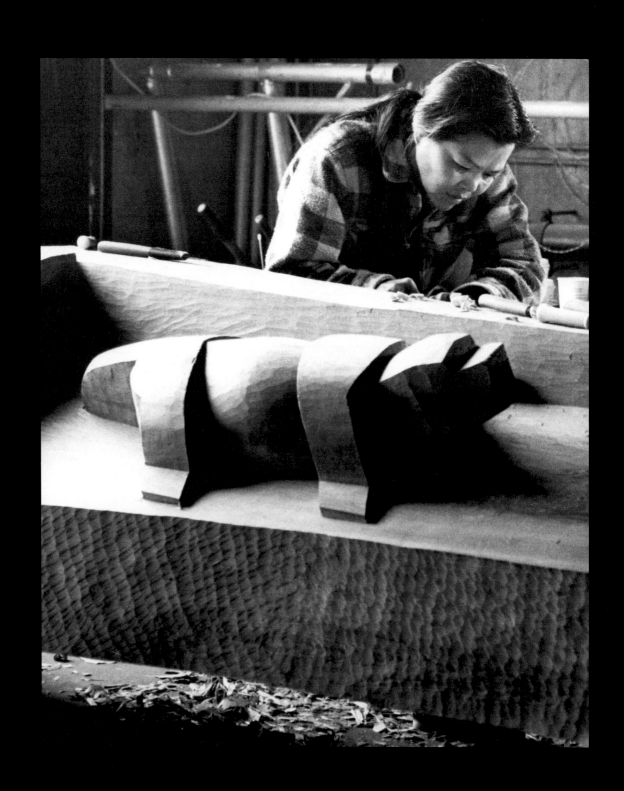

Susan Point: Her Place by the River

The pale March sun has just enough warmth to herald the arrival of spring. Alder, maple and chokecherry trees on a terrace rising above the Fraser River delta show tentative signs of flowering, but the cattails on the mud flats below remain sere, their papery blades yet to regenerate. Downstream, in the distance, the marsh merges with the horizon, in a muddy convergence of river and sea. The scene is remote, pastoral, idyllic. It is difficult to conceive that a metropolitan area housing two million people surrounds this quiet retreat where no evidence of habitation is visible. Only the occasional scream of jet aircraft landing and departing from the nearby international airport or the comforting hum of a diesel-driven tugboat nosing through the river's brown water disturbs the tranquillity of the moment.

Coast Salish artist Susan A. Point sits at the edge of the Sto:lo—"the River"—as it translates from the Hun'qum?i'num language of her people. As the silt-laden water rolls by, she reflects upon her youth, growing up on the Musqueam Indian Reserve adjacent to, but a world apart from, the boisterous city of Vancouver. She recalls that in the 1950s, when she was a young child, her community was small, no more than three dozen houses clustered in two residential groupings. Amenities on the reserve were minimal: electrification was a recent phenomenon, indoor plumbing unknown, and water for household use was carried in buckets from a communal tap.

A combination of high tide and spring melt brought flood water to the doorstep of the family home. This enabled Susan's father, Tony Point, to beach his gillnet boat nearby so that he could recaulk, paint and otherwise prepare it for the coming commercial salmon-fishing season at River's Inlet, 400 km (250 miles) to the north. It was on one of these yearly expeditions that Susan was born in Alert Bay on April 5, 1952. She laughs at the irony of her birth in Kwakwaka'wakw territory.

The daily routine was always busy in the large Point household that included her parents, seven siblings and the revolving presence of eight older half-siblings from her father's and mother's previous marriages. Their days were remarkably akin to the traditional Musqueam round, with salmon fishing, both commercial and subsistence, dominating the months from April through October. Spring activities included gathering the succulent shoots of salmonberry bushes, a sweet delicacy, and trips to Burrard Inlet to gather shellfish. Summer brought the harvesting and preserving of cherries, blackberries and salal berries for enjoyment during the winter months. Because refrigeration was unavailable, the late summer sockeye salmon catch was smoked as well as salted and stored in barrels for the family's winter use. Other fish caught in the intertidal zone and upriver included flounder, sturgeon and eulachon (another fish that they smoked). Ducks and geese, hunted by Point's father and brothers on the adjoining river flats, were also a staple part of the diet. She grimaces, recalling: "I hated plucking those ducks and having to deal with the mites on their bodies, but we had to do it. Mom made our pillows and mattresses from the down."

Susan Point at work
Photo: Jeff Cannell

Susan cannot remember her mother, Edna Grant-Point, ever being idle, whether working at northern canneries or employed locally at B.C. Packers in Vancouver or West Vancouver. Mrs. Point also laboured in the market gardens on reserve land rented to Chinese tenant farmers, and she cut cordwood with her husband on the downstream flats. With the assistance of her children, she cleaned, teased, carded and spun the fleece of domestic sheep into yarn, which she then used to knit the famous Cowichan sweaters, as well as vests, socks and mittens. Skilled in traditional Salish arts, she had been trained as a girl to weave cattail mats and coiled, imbricated basketry. One of Susan Point's cherished possessions is a basket made by her mother, part of a collection of Salish baskets that includes examples created by four generations of maternal forebears.

Elementary schooling was taken nearby in an encroaching Vancouver suburb until, at the age of nine, Point was sent, as she expresses it, "by government decree to Sechelt Residential School for five years, a heartbreaking experience." She has no wish to expand upon those unhappy times being away from her family. After returning home, she attended Point Grey High School, where she completed grade 11. She entered the labour force at age sixteen, working at a cannery along with her mother; at seventeen, she got a position as a secretary for the Musqueam Band, then as a secretary with the Union of B.C. Indian Chiefs and, later, as an executive secretary with the Alliance Tribal Council.

In 1981, Point enrolled in a six-week jewellery-making course offered to First Nations students by Vancouver Community College. The instructor, Jack Leyland, emphasized modern precious metalsmithing techniques, including soldering, brazing and engraving. The learning process and the technical mastery of tools and materials was, for the aspiring student, more important than actual design. This pivotal experience established a pattern of intellectual and artistic inquiry, built on the foundation of self-discipline and hard work learned from her mother, which Point repeated in the ensuing decades, seeking instruction from a range of experts in order to understand and then master a medium. Design, as became apparent, she could explore and develop on her own.

Upon completion of the jewellery course, Point followed the example of her fellow students, making jewellery with Northwest Coast motifs. Engraved on bracelets and rings, her applied designs were derivative of the northern Northwest Coast formline style, a style that she admits she never mastered nor was comfortable with. Her husband, Jeff Cannell, asked if there was an art form of her own people. At about that same time, Susan and her husband discovered a suite of serigraphs by Coast Salish artist Stan Greene. These were primarily interpretations of extant Salish spindle whorl designs. She acknowledges that Greene's renderings quickly led her to an expanded perspective on these magical disks, and their circular form has dominated her work in a wide range of materials and mediums ever since.

Traditional spindle whorls are disks fashioned from the wood of the broadleaf maple tree, about 20 cm (8 inches) in diameter, with a centre hole through which extends a spindle shaft that is 90 cm (36 inches) long (see below). The whorls are decorated on the convex side—which faces "down" when the spinner is spinning—with floral, geometric or anthropomorphic designs. The latter are said to be images representing the spinner's spirit helpers and are intentionally ambiguous so as not to reveal the specific bird, mammal, fish or other creature that serves as an inspirational guide.

Not totally familiar with Salish art, Point sought advice from the husband of her aunt, Della Charles Kew. The guidance of Professor Michael Kew, an anthropologist at the University of British Columbia, was a revelation. He introduced her to Coast Salish artifacts in the Museum of Anthropology at the university and shared his collection of slides, photographs and published images, as well as directing her to collections in other North American museums. She explains: "Every spindle whorl I saw intrigued me. They became primary subjects of my prints and other works. I now know those old carved whorls so well that I feel I can identify the makers of them by personal style."

Weaver working with a traditional spindle whorl
ca. 1920s
Collection of the Royal British Columbia Museum
Photo: Courtesy of the Royal British Columbia Museum, Victoria, British Columbia, Catalogue no. PN 88

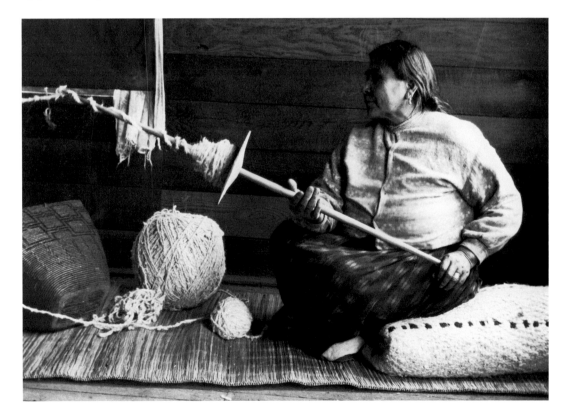

Quickly comprehending the unique Coast Salish two-dimensional style and bolstered by Greene's example, Point decided to explore and experiment with the print medium. On quiet evenings, she began to sketch with pencil and paper. After reworking a single idea many times, she produced her first original graphic design, a black-on-white painting depicting four salmon contained within a circle, which was reproduced in April 1981 as her first serigraph, titled *Salmon* (see facing page). Its circular format paid tribute to the spindle whorls that she had examined extensively in museum collections, but the design was entirely her own.

Her second print, produced in the same month, was based on a spindle whorl carved by an unknown nineteenth-century Cowichan master (see facing page). She chose to interpret the figures incised on it, as the title of the work indicates, *Man and Sea Otters* (see facing page), although other meanings are possible for this configuration. Point began applying Salish two-dimensional designs to her jewellery as well as to her prints. But they were difficult to sell, as the established galleries specializing in Northwest Coast art were unwilling or unable to recognize the aesthetics of the Coast Salish art form.

The use of an older work as a reference heavily influenced Point's designs over the ensuing decade. She explains: "My rapid mastery of the design form resulted, in a sense, because I was copying. Everything was already in place; it looked as if I knew all about it but I really didn't." This humble statement belies the fact that much of her early work was innovative and experimental, not only in terms of design but in matters of technique. A review of the more than one hundred prints produced in that ten-year period reveals she had reached a mature and independent understanding of the classic Coast Salish form early in her career. Although she always honoured the integrity of the old designs, she consciously tried to improve them by introducing her own interpretations of detail where appropriate.

Point printed her first images at home on the kitchen table; her children helped by running the prints to any available surface in the house to dry. The edition sizes were based on the number of successful prints the family was able to pull, rather than any predetermined number. The early works were all produced from precise black-and-white paintings that were turned into film positives. Increasingly, she attempted technically more difficult prints, blending and overprinting colours, creating designs that required three- or four-point colour registration. When working at this degree of complexity, the medium is unforgiving, and, while the technical mastery of her later prints may not readily be appreciated by all, professionals in the printing industry recognize that her serigraphs are technically superior to many available on today's market. Currently, she works on a print design through several successive stages, beginning with a rough concept hastily sketched, then a series of tracings to a final line drawing created with a 3H pencil. Even though the resultant line is absolutely precise, she will instruct the printer to cut on one side or the other of the line at critical junctures in order to maintain the integrity of her original form.

TOP *Salmon*, 1981
serigraph
edition of 45
20 × 20 inches
Photo: Kenji Nagai

BOTTOM LEFT Traditional
spindle whorl
nineteenth century
Collection of the Royal
British Columbia Museum
Photo: Courtesy of the Royal
British Columbia Museum,
Victoria, British Columbia,
Catalogue no. 2454

BOTTOM RIGHT *Man and
Sea Otters*, 1981
serigraph
edition of 100
20 × 22 inches
Photo: Kenji Nagai. Courtesy
of Gene Joseph, Potlatch Arts

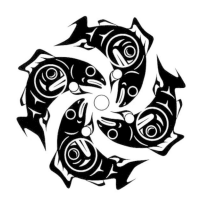

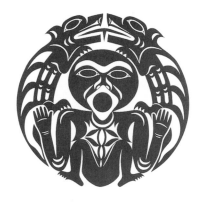

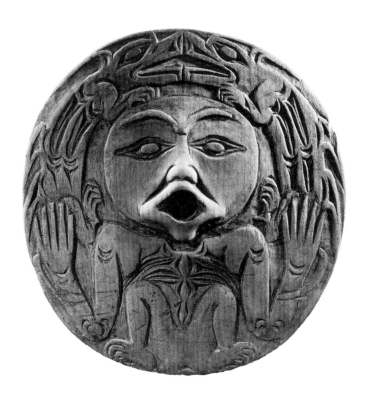

Fascinated by the potential of blending colours, Point began experimenting with this technique following a formal course of training with master screen printer Bill Watson. He introduced her to Walter DeJong of Prism Graphics, who printed with her for a number of years, beginning with *Kwantlen*, her first serigraph to incorporate the blending of colours, in July 1983. There was an immediate reaction to the print by critics, who claimed that it was not representative of traditional Northwest Coast art. Point recalls: "It was scary, introducing my own sense of colour. People reacted negatively, telling me it wasn't Coast Salish art. It took a long time until it was accepted." Her palette is unique among Northwest Coast artists and is admittedly contrary to the dictates of traditional Northwest Coast colour schemes. Her colour sense is the result of a six-month interior design course she took in 1978, which also influenced her approach to layout and design.

By 1986, Point was ready to explore other printing techniques, beginning with a series of 23-carat gold foil–embossed prints. She produced her first woodblock print in 1987, and in the following year created her first paper casting, using handmade cotton paper. In 1988 she produced her first linocut print on handmade cedar bark paper. The offset lithograph with the title *Different Perspective* was printed in 1992 from an original painting by the same title (see facing page), a major work in acrylic that further demonstrates Point's artistic and intellectual rigour. Her varied training and the attendant influences are ultimately reflected in the minimal, subtly hued yet intellectually accomplished serigraph *Becoming One*, produced in January 1997.

Not widely known are Point's acrylic paintings on canvas, some of which have also been published in serigraph versions, such as *Survivor* (see page 32) and the aforementioned *Different Perspective*. Painting has provided her with a format for a deeper, less restrictive exploration of social, environmental and personal issues. *Survivor* is an example of the latter, although she is reluctant to reveal its full meaning other than to indicate that it deals with the loss of loved ones. *Voices of the Earth* is in a sense a straightforward statement about environmental issues, rendered in pastel tones that subtly depict the stumps of a ravaged clear-cut and the pollutant-spewing smokestacks of a pulp mill in the background. These disappear into receding ranges of hills. The attentive viewer might be startled to recognize the strong environmental statement which, at first glance, is camouflaged by the gentle colours.

Largely self-taught, Point is constantly seeking new ideas and new mediums and, when intrigued by the latter, she will find an established professional or teacher and arrange an apprenticeship that allows her to understand the demands and the potential of the material. She then creates works that she considers can be successfully rendered in an unfamiliar and challenging material. Glass is one new material that she has been exploring in the past decade. Tentative experimentation with frosted images on mirrors and glass in 1986 led to a search for a more challenging use of this medium. Ever practical, she turned to the *Yellow Pages* and found a

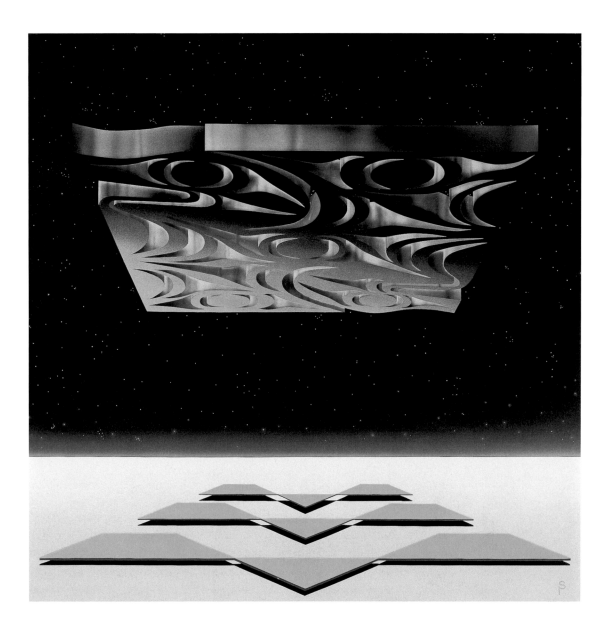

Different Perspective, 1992
acrylic on canvas
48 × 48 inches
Collection of the Royal British
Columbia Museum
Photo: Courtesy of the Royal
British Columbia Museum,
Victoria, British Columbia,
Catalogue no. 19751

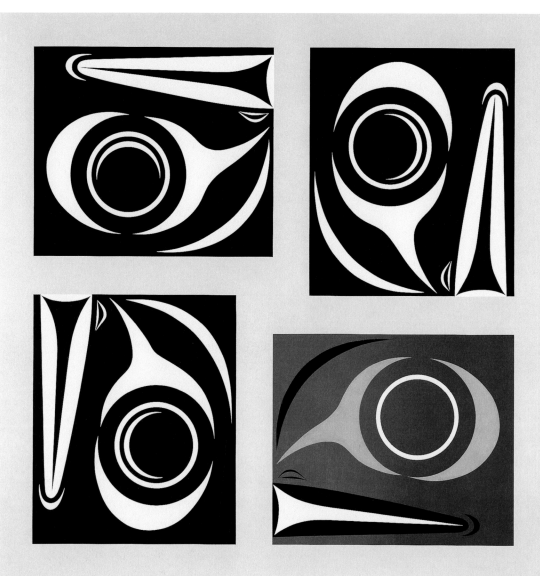

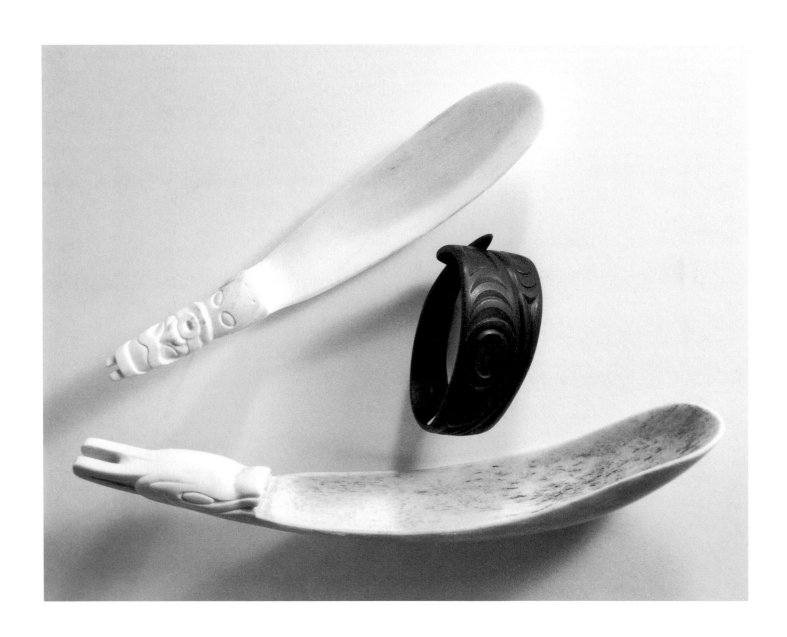

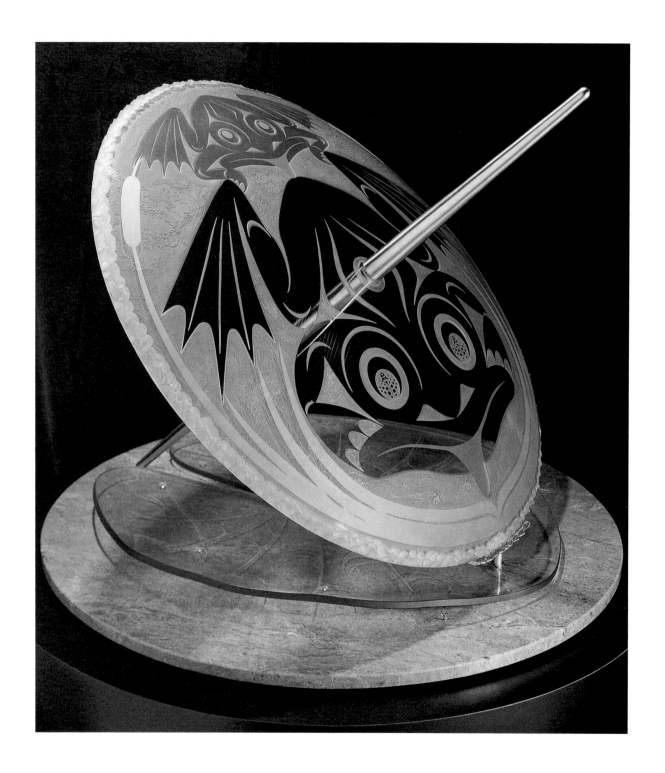

glass studio where the artisans were pleased to discuss the many applications she envisioned. Her first successful use of glass, in her opinion, was her *Land, Sea and Sky* installation at Vancouver International Airport in 1993, a multimedia work celebrating the juncture of these three elements at the westerly edge of the Fraser River delta, where the airport now dominates Musqueam territory's most productive lands. In this work, land, sea and sky are represented, respectively, by wolves, salmon and eagles. In a departure lounge, glass panels, incised with the aforementioned animals, adorn the building's support columns. A large horizontal panel of red cedar planks, featuring a wolf, killerwhale and eagle, continues the theme. The walls of the lounge are hung with a selection of Point's serigraphs, completing the Coast Salish context.

By 1994, Point was producing plates, shields and vertical totem images in glass, applying various finishes using sandblasting, casting and abrasive cutting. Although she is no longer directly involved in the hazardous aspects of the glass process, she is always available, when a project is underway, to ensure her concepts are executed to her exacting standards. The spindle whorl re-emerges in this medium, with designs both classically anthropomorphic and geometric manifest in a series of limited editions that include spindles of both brushed stainless steel and laminated wood (see facing page). The glass spindle whorls are increasingly much larger than actual ones, and some now approach a monumental scale.

The easily worked aromatic red cedar tree defines the material culture of Northwest Coast people. From it, houses, monumental carvings, canoes, and ceremonial and everyday articles were and are fashioned by skilled artisans trained to understand the wood's every nuance. Initially hesitant to tackle wood, Point was encouraged to do so by Bud Mintz, the owner of Potlatch Arts gallery in Vancouver, who had been a friend and mentor since 1981. She turned to John Livingston, a non-aboriginal carver and instructor who had been trained in carving, painting and design by Kwakwaka'wakw artists Henry and Tony Hunt in Victoria in the late 1960s. In 1990, Livingston helped her to execute a three-piece carved red cedar panel for a theatre/museum complex on the Sechelt Indian Reserve in southern British Columbia. From a technical point of view, it was an ideal beginner's project, given the familiar two-dimensional format, which effectively required little more than a series of precisely engraved linear cuts coupled with a complex of crescents, wedges and U-forms. Livingston has commented that Point was a fast learner; because she had already mastered design, he had only to instruct her on how to wield adzes, chisels and an array of knives with varying blade forms, admittedly a formidable undertaking.

A year after her introduction to red cedar, Point carved her first house post (in the round), a 3.6-m (12-foot) structural post for the First Nations House of Learning on the University of British Columbia campus. Because of engineering limitations, she could cut no more than 10 cm (4 inches) into the 122-cm (48-inch) diameter log. Again, this project served her established capabilities as a designer; the result was a Raven with its folded wings elaborately engraved in

the Coast Salish style, standing atop a spindle whorl. An added piece, extending the Raven's beak, was mortised on, giving more dimension and presence to the bird. Contrary to traditional Northwest Coast carving methods, Point first prepared a scale model to help solve issues of proportion and placement before taking adze to wood. Since carving her first house post in 1991, she has completed eight others: a male and female welcome figure at Vancouver International Airport; a welcome figure and two house posts for the University of British Columbia Museum of Anthropology (inspired, at their request, by nineteenth-century prototypes that once stood on the Musqueam Reserve); and three for her year 2000 solo exhibition (see pages 95 and 96). Recently, and to good effect, the artist has begun to add copper and bronze insets to her house posts.

More than any other contemporary Northwest Coast artist, Susan Point has been successful in securing public art commissions due to her desire for new challenges, her willingness to explore new mediums and her ability to work on a massive scale in concert with architects and engineers. These architectural projects have given her the opportunity to experiment with such non-traditional materials as cast iron, stainless steel, coloured glass, bronze, fabric, concrete and polymers. Her early success in winning public art competitions brought her work to the attention of architects, who now seek her direct collaboration for projects.

Point began modestly with projects to paint a bus shelter and design cast-iron tree grates for the exceptional King County Public Art Collection that consists of more than a hundred major public installations in the buildings, plazas and streets of downtown Seattle, Washington, and its surrounding environs. She was one of five artists selected to produce designs for a cast-iron "tree grate museum" in the downtown core. Her submission, destined to surround the sidewalk-level bases of red oak trees, is an Escher-like flight of bird, acorn and oak leaf motifs expanding from a central circle encompassed by a frame composed of geometric design elements found in Salish weaving (see facing page). Through this modest work, Point achieved a significant public profile in the Seattle area and has since secured several major public commissions in the city. These include *Northwind Fishing Weir Legend* (commissioned in 1992), a six-piece concrete, granite, copper and cedar installation placed alongside an ancient Native American fishing site on the Duwamish River; *Water, the Essence of Life* (commissioned in 1993), a mixed-media building facade at the West Seattle Pump Station, and the intellectually and mathematically challenging installation on an exterior wall of the High Tech Learning Center building on the North Seattle Community College campus.

Before producing the design for the High Tech building, Point toured the campus site and discovered it was built alongside a spring used by generations of First Nations people. She was also impressed by the multicultural profile of the student body of the college. Her resulting concept, *Four Corners* (see page 38), began with the creation of four human faces, each representing a

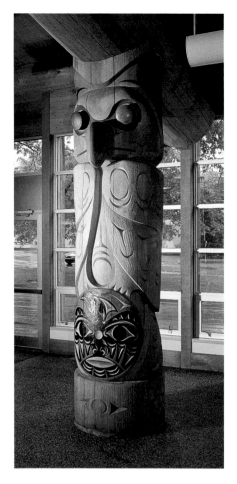

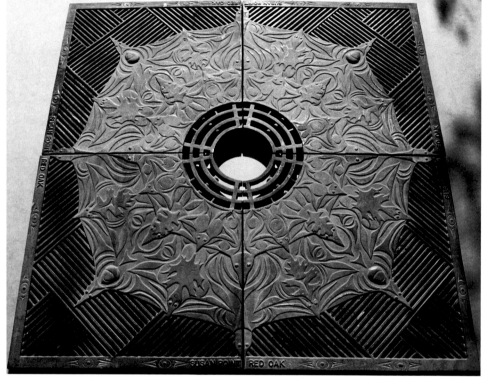

ABOVE House post, 1991
red cedar
12 × 4 feet
Photo: Bob Matheson

RIGHT Red oak tree grate, 1986
cast iron
5 × 5 feet
Photo: Glen Laufer

person from the continents of North America, Africa, Asia and Europe. Each face is contained within a square set on point so that, when split horizontally, two opposing triangles result. The upper half includes the eyes, nose and brow while the lower incorporates the mouth, cheeks and chin. Thus, the four primary faces can be reconfigured to create a total of sixteen variations, representing all of humanity. The faces are cast in a commercial polymer, pigmented a terra cotta colour to represent the red clay found in a natural deposit around the spring. They are set into the cast concrete of the building facade, which is a stylized representation of the stream that once emerged from the spring. Wavy lines, representing rills of flowing water, form the ground behind each face.

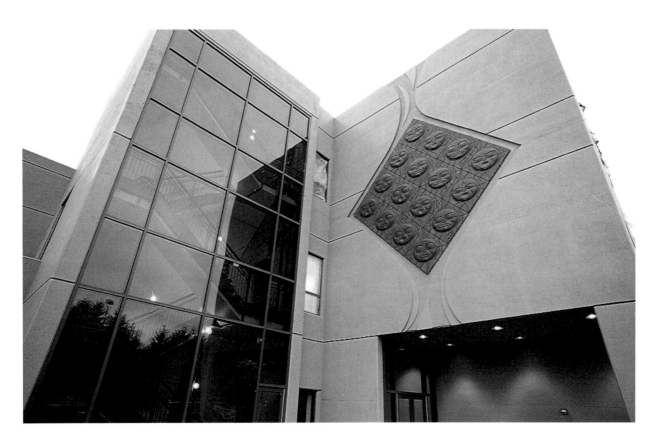

FACING PAGE *Four Corners*, 1997
20 × 20 feet
terra cotta, polymer
Photo: Bob Matheson

RIGHT *Spawning Salmon*, 1990
bas-relief cast in concrete
10,000 square feet
House of Hewhiwus, Sechelt,
British Columbia
Photo: Bob Matheson

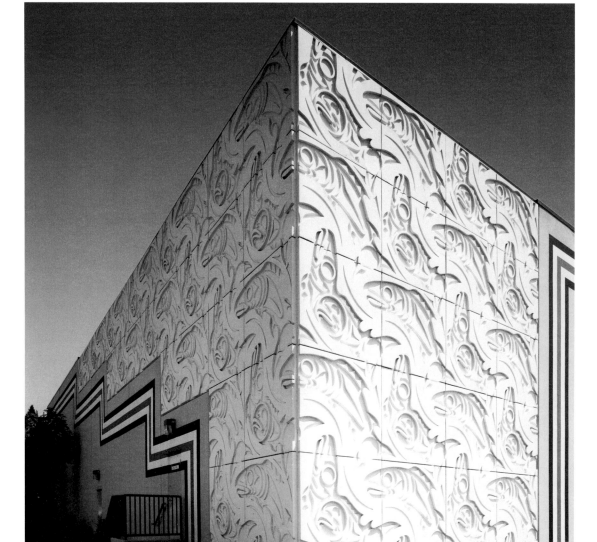

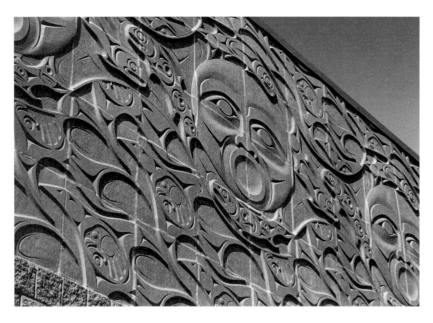

Pump Station, 1993
cast concrete
1,000 square feet (approx.)
Photos: Bob Matheson

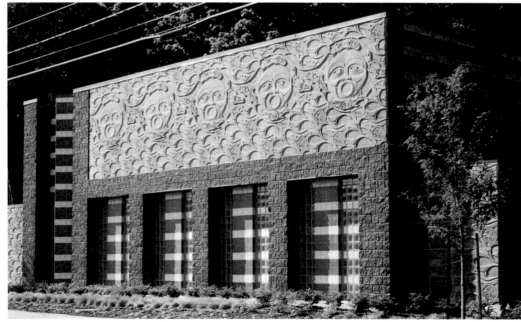

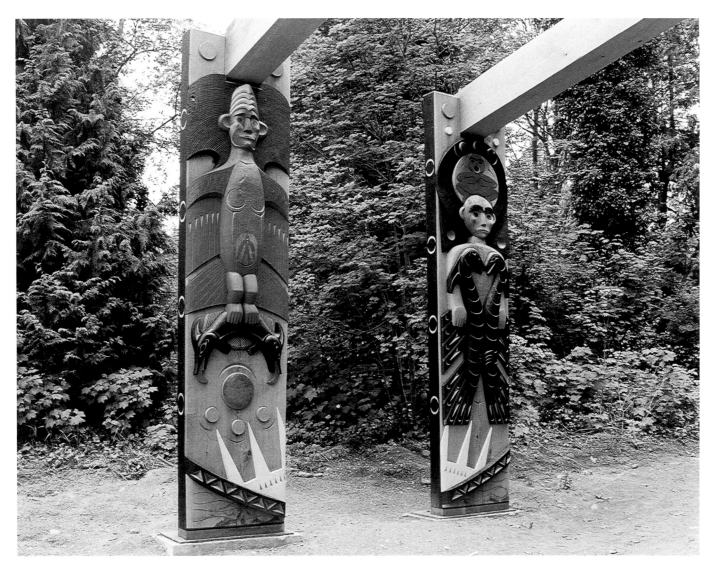

House posts, 1997
red cedar
14 × 4 feet
Collection of the University of
British Columbia Museum
of Anthropology
Photo: Bob Matheson

Point's architectural installations for the Sechelt Indian Reserve complex in British Columbia and the West Seattle Pump Station in Washington state are even more complicated: all the exterior structural walls are clad with cast-concrete sections decorated in bas-relief. The Sechelt example (see page 39) is particularly brilliant because Point designed two panels which, when put together in an aggregate of six, complete the motif of a leaping and diving salmon. A similar concept applies to the Pump Station: the design panels are configured to complete two thematic images (see facing page). The theme is continued in the metal fence and gates surrounding the building.

Increasingly, architects and designers are introducing Native American forms and images into modern buildings. As far as Northwest Coast themes are concerned, these applications have generally been traditional and conservative, such as the installation of a totem pole, a painted or carved cedar panel, or a bronze casting in a lobby or on an exterior facade. Susan Point has gone far beyond that in her imaginative and inventive use of material and form, demonstrating

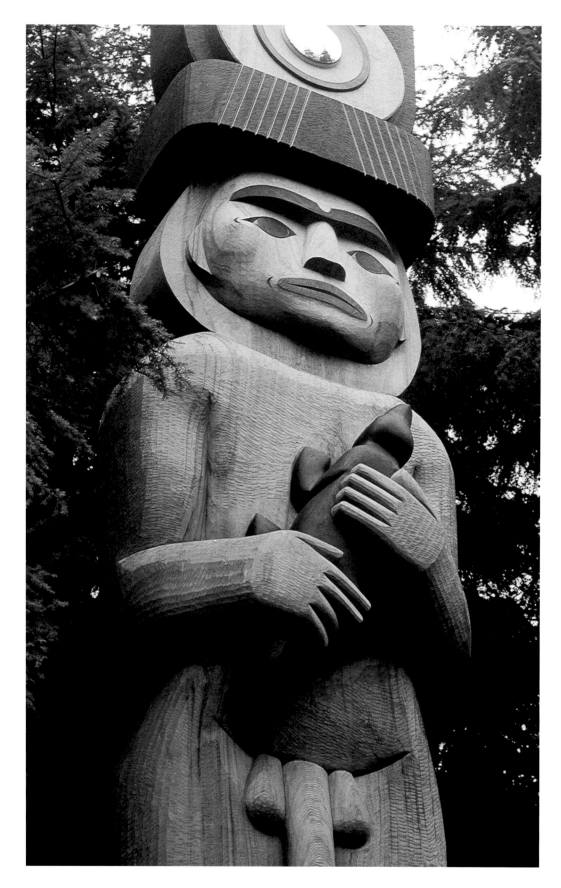

Welcome Figure, 1996
red cedar, copper
22 × 4 feet
UBC Museum of Anthropology
Photo: Bob Matheson

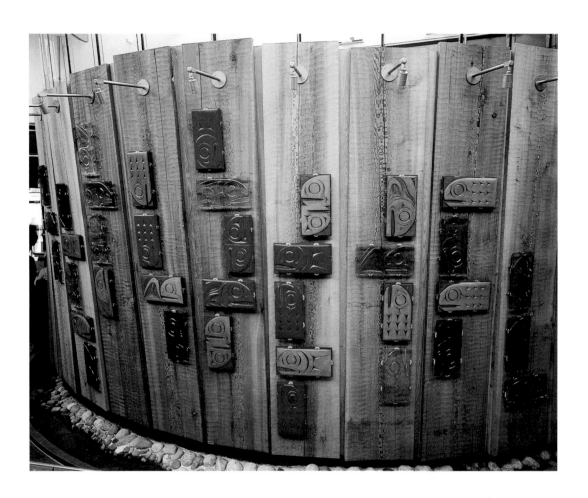

Coming Together, 1998
cast glass and terra cotta polymer
7 × 20 feet
Langara College, Vancouver,
British Columbia
Photo: Kenji Nagai

a creative and leading-edge application of the Northwest Coast art form that has yet to be considered or matched by her contemporaries. Her use of structural concrete castings and truly integrated applied designs where scale has been greatly expanded set her work apart.

Susan Point's approach to her art is visionary, innovative and exacting. She has brought the two thousand-year-old Coast Salish art form—which many scholars see as the ancient prototype for the more recent formalized and intellectualized two-dimensional art of the northern coast—to a position of admired and deserved appreciation, giving it new life and definition, an encouraging introduction to the new millennium.

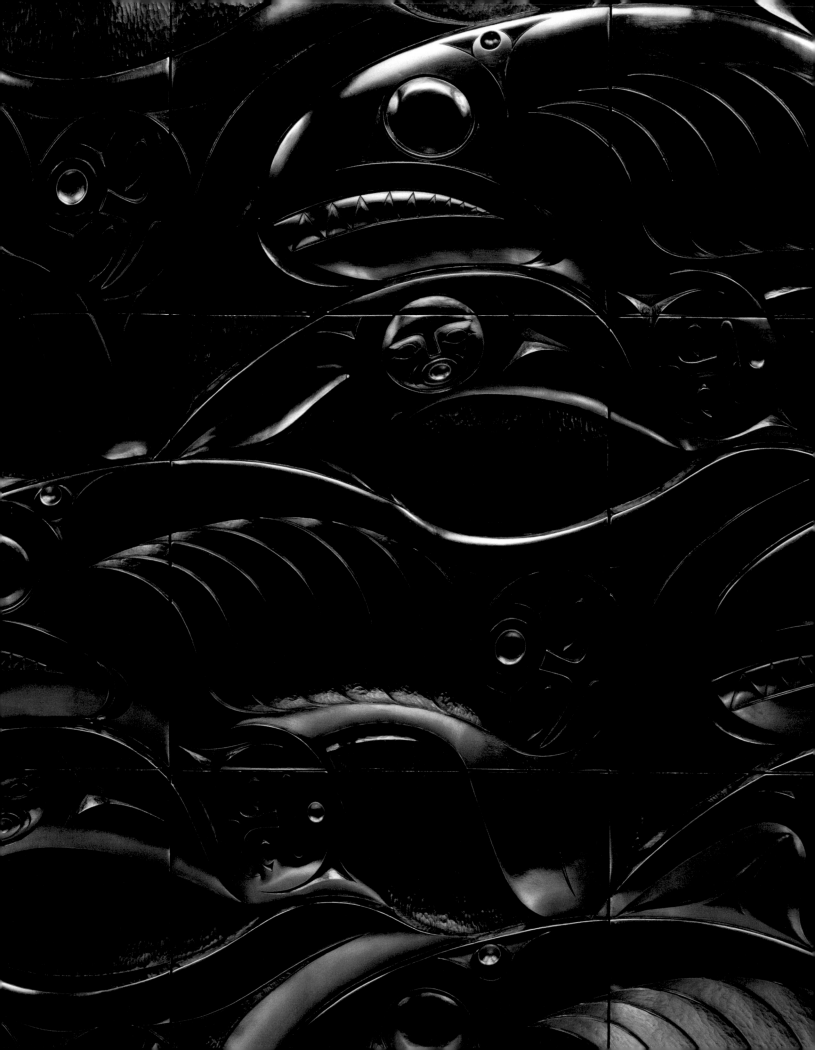

More than any other contemporary Northwest Coast artist,

Susan Point has been successful in securing public art commissions

due to her **desire for new challenges**,

her **willingness to explore** *new mediums and*

her **ability to work on a massive scale**

in concert with architects and engineers.

—PETER MACNAIR

In a fine piece of music, a grand theme is often punctuated by a smaller theme that echoes continuously and effortlessly from beginning to end. *Consonance*, by definition, implies harmony and agreement among components, or a dialogue or recurrence of repeated sounds. Looking at Susan Point's visual interpretation of consonance brings to the viewer the same ease and satisfaction that Mozart and Beethoven often bring to concert halls as their rhythms and melodies resonate with our own internal rhythms and need to find order in the world around us. In some ways, viewing Susan Point's piece provides a sense that there is an important and unique place for every creature and every idea in the greater scope of creation.

The inspiration for *Consonance* came to Point from the Salish legend of the Whale People, which tells of the village's two fastest warriors, who were chosen to run each day to a lookout point, searching for enemy canoes from villages to the north. One day the two warriors saw people far away on the beach, and they moved in closer for a better look. They discovered not humans, but a group of whales with their *qwalow'*, or skins, pulled over their shoulders, revealing their human form. One of the runners raced toward these Whale People, hoping to capture one. The Whale People dove back in the water, but because the runner was so fast, he managed to grab one of the *qwalow'*, allowing only the human form to escape.

The second runner warned the first to return the *qwalow'* or suffer bad luck, but the first runner only scoffed at him and took the *qwalow'* home. Nightmares descended upon him as

he slept that night, and they continued every night after. Misfortunes followed him everywhere. Realizing his mistake, he decided to return the *qwalow'* to the Whale People. They were grateful, and from that day on, they blessed the runner with the greatest of luck.

Susan Point portrays the human qualities of the orcas in this piece. In First Nations tradition, the orcas are believed to symbolize long life. The orcas' human forms, as well as the kinship humans share with the whales, are represented by the human faces that appear on each of the fins. In *Consonance*, Point reminds us that all life is connected and that the whale and humans are both part of Mother Earth's family. The whole of existence is the sum of its parts. Although only fifteen components are displayed, the piece clearly has no beginning and no end.

"The imagery in this piece, like many of my other pieces," Point explains, "is to show respect—in this case, to the whales. And to remind us of our obligation to look out and care for these magnificent creatures, who are believed to be very closely related to humankind."

Consonance was created from castings of two moulds, taken from two original patterns hand-carved in yellow cedar and finished with a bronze polymer.

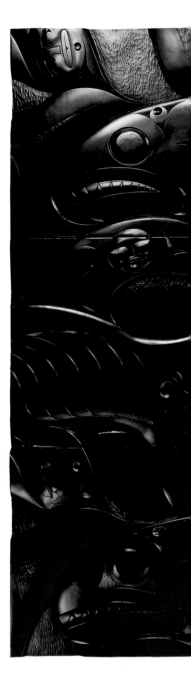

Consonance
2000 | bronze, polymer | 54 × 90 × 3.5 inches

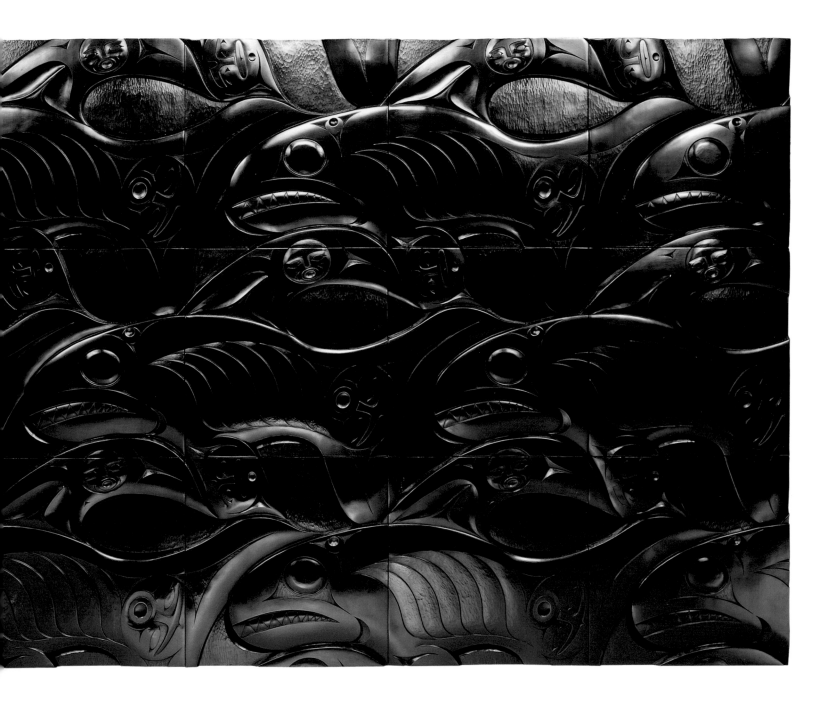

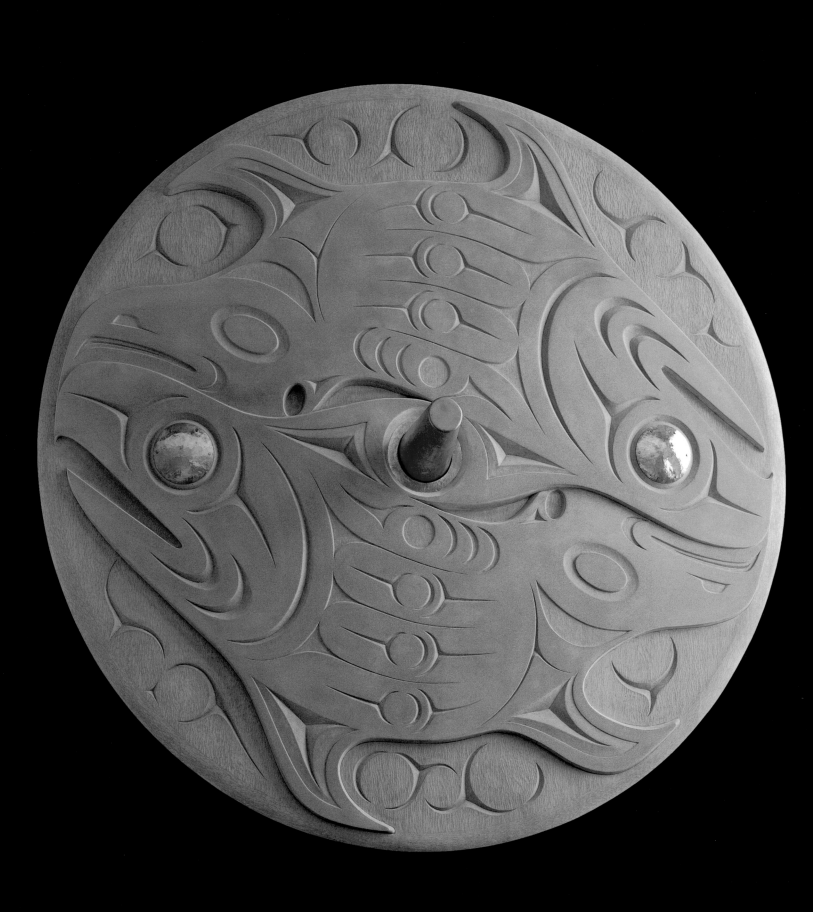

For thousands of years the powerful Fraser River, where Susan Point's two sons still fish, has been home to the Musqueam, used for travel, a source of food and a source of myth. Musqueam history is rich with legends of this river and its people. With Point's dramatic 2-m (7-foot) spindle whorl, *The River—Giver of Life*, it also becomes a metaphor for the cycle of existence, not only for the salmon who depend on it for passage to spawning grounds, but for all life on the planet. It's a reminder of the journey we each undertake, and the turbulence, perils and beauty that affect us all.

Specifically, this piece symbolizes the north arm of the Fraser, which is most closely linked with Musqueam life today as it passes along the south shores of the community's border. With water flowing in the background, *The River—Giver of Life* depicts two salmon swimming in a circle. One swims inland to spawn and the other out to sea, completing their life cycle. Salmon are considered symbols of life, wealth and good luck to the First Nations people. In this instance, they are also a reminder that the Coast Salish people still fish along the river.

Moving in opposite directions to the salmon are two magnificent thunderbirds. According to First Nations mythology, the thunderbird, living high in the mountains, is the most powerful of all spirits. "When the thunderbird flaps his wings," Point explains, "thunder crashes and lightning flashes from his eyes." In *The River—Giver of Life*, these thunderbirds, seen in the salmon tails, are transferring their power to the salmon, protecting them and overseeing their continuing cycle of renewal. In traditional First Nations style, the thunderbird closely resembles the eagle and can be distinguished by its circular ear high on its head. The contemporary style of this piece also reflects the spirit of the Pacific Northwest and the traditional style of Coast Salish art, using such design elements as crescents, U-forms and V-forms or wedges.

The spindle of the whorl is leafed in copper and the eyes are copper domes, but structurally, Susan Point has chosen to create this piece entirely as a sand cast. This technique involves pouring a mixture of sand and a polymer resin into a mould. The use of sand further demonstrates the commanding presence every aspect of the Fraser River has in the lives of the Musqueam people. The sand moves through the twists and turns of the river as it flows out to sea, not unlike how members of the community must navigate their own journey through life. Sand is also a marker of time, which keeps moving regardless of how we attempt to control it.

The River — Giver of Life
2000 | ruby sand, polymer, steel, copper | 7 feet in diameter × 18 inches

Paper Cast Variable Edition of Three

These three impressive works of art, *Speaking Great Silence, Singing the Season* and *Raven's Song*, each make powerful statements. A trilogy, their voices echo through the heart of a viewer as few other pieces can. Each of the wall-mounted sculptures carries through the theme of voices and listening to nature. Susan Point has given each work a unique voice and message. The trick, from a viewer's standpoint, is to be available to listen.

Each piece of this limited edition set features a face, approximately 1 metre (40 inches) in diameter, lying in the centre of its design. On each of the

faces, which are cast in different colours of paper, the lips are pursed, illustrating the sounds and messages that form the overall theme of the group. Behind the faces are individual mounts that elaborate on the story of the individual piece.

The first sculpture in the trilogy, *Speaking Great Silence*, features a face cast in paper made from cedar bark. Other sculptures by Susan Point (three house posts and a beam) also came from the same tree that provided this bark, as did the carved mould for the three paper casts. For Point, this fact emphasizes the nature of the piece. "The title," she explains, "reflects the loud silence experienced when deep in a dark forest of towering cedar giants."

The carved red cedar mount for *Speaking Great Silence* is a disk approximately 1.5 metres (60 inches) in diameter. Around the face are carved and painted deer. The deer is an animal known for its ability to move silently through the forest. Silence can be one of the most frightening and most powerful sounds humans can experience. It is often our discomfort with, or outright fear of, silence that causes us to attempt to drown it out with needless talk and noise. Unless the mind is quiet, silence can be difficult to even hear and appreciate.

Speaking Great Silence
2000 | handmade cedar bark paper, red cedar
60 inches in diameter × 24 inches (approx.)

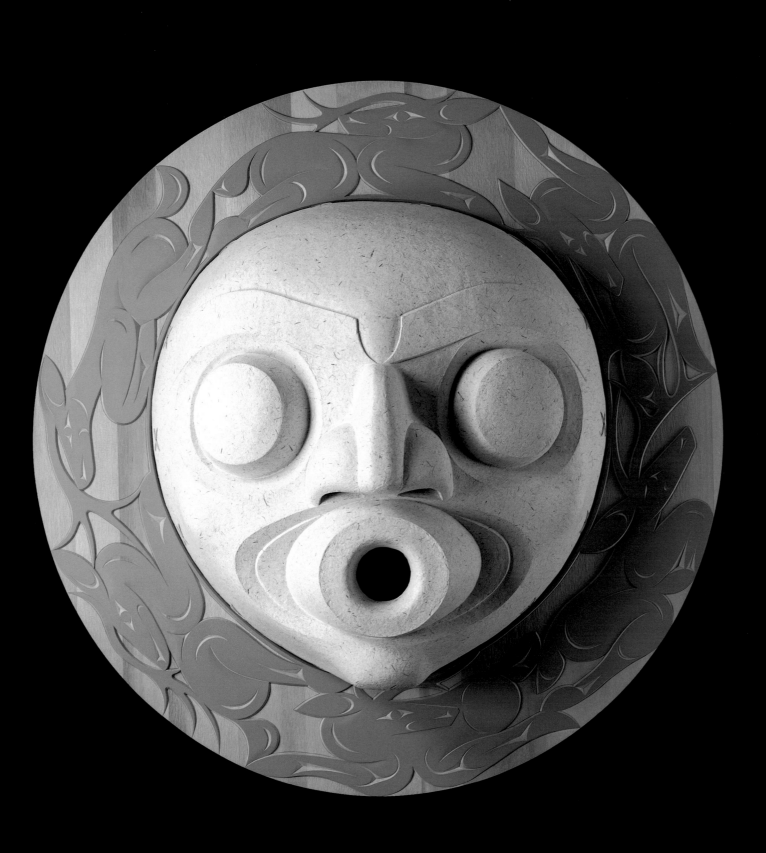

The second piece in the trilogy, *Singing the Season*, brings Susan Point back to a creature and theme she enjoys revisiting. Point loves creating frogs and learned as a child that listening for the frogs to begin singing was the first sign of spring. When the frogs stopped singing in late fall, Point knew that the quiet months of winter had arrived. Thus, the frog's voice has been a trusted marker of time in the Musqueam community. As development and urbanization encroached on the frog habitat, the song of the frog has been harder for Point to hear. Now it seems the frogs, with their growing silence, are singing an alarm; the balance of nature is in danger and time is running out.

The face in *Singing the Season* is cast in brilliant green paper and is trimmed along the edge where it meets the mounting section with a reddish-coloured cedar bark rope. The panel for mounting the face is rectangular. The carving and the shape of the wooden back represent a headdress and woven blanket. Five frogs, each with silver domes for eyes, are carved above the face. In the shoulder area, a carved Salish weaving pattern appears.

Singing the Season
2000 | handmade green cotton paper, red cedar, silver, cedar bark rope
4 feet × 5 feet × 24 inches

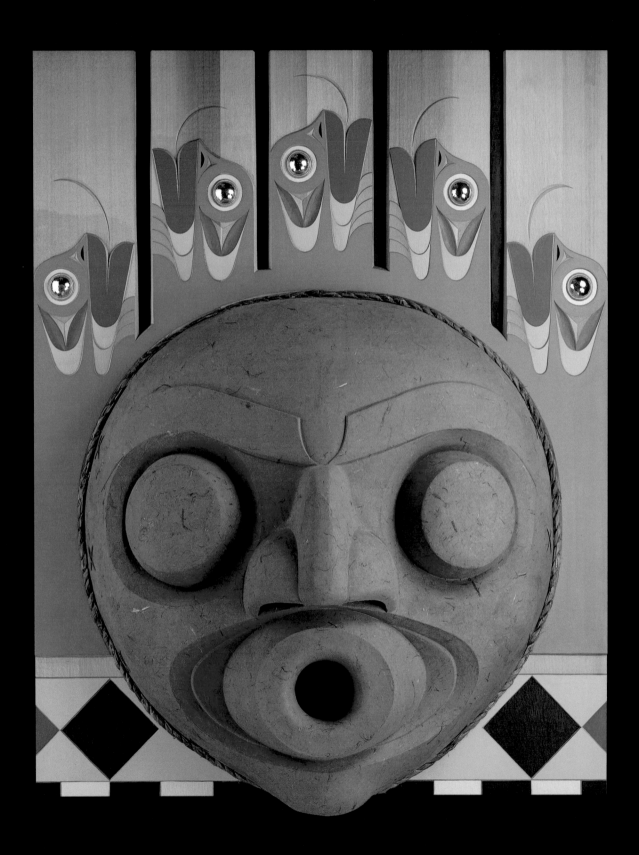

In the third and final piece in the trilogy, *Raven's Song*, the face is a deep purplish burgundy. The mount is a 1.6-m (64-inch), carved, yellow cedar rim with a raven coming up either side from the bottom. The raven symbolizes transformation, and the human form carved within the raven's body reflects the need for humans to transform themselves, to embrace and value the natural world. Thus the raven's song invites us to rise above our earthly forms and limitations.

Raven's Song
2000 | handmade burgundy cotton paper, yellow cedar, acrylic paint
64 inches in diameter × 24 inches (approx.)

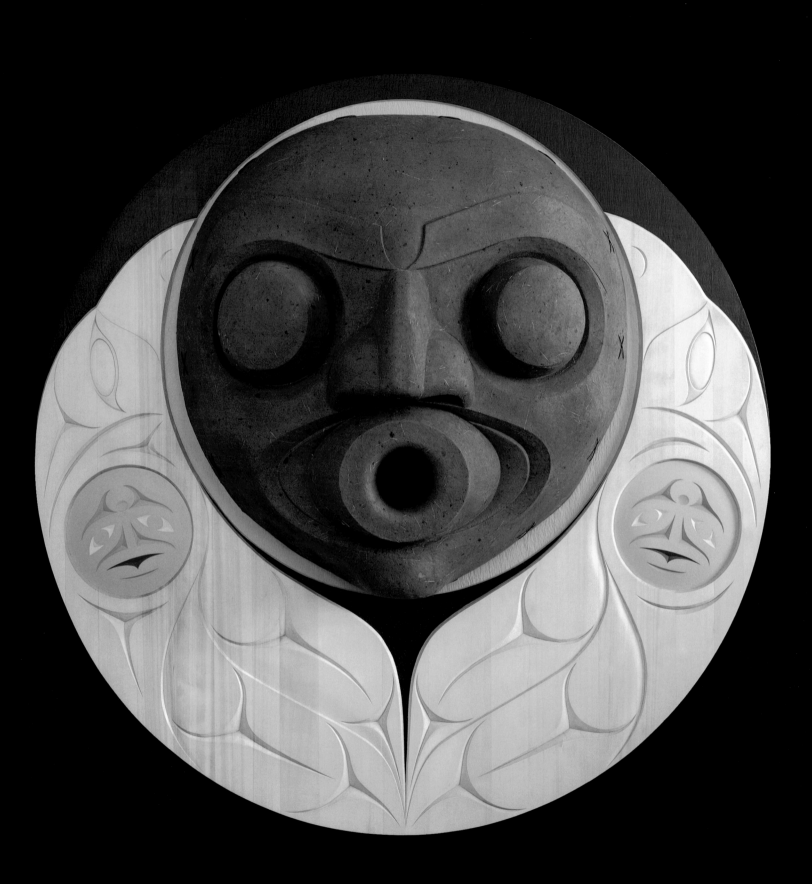

Salish Revival

This painting, with its deep waves of life-red colour, is a tribute to the Coast Salish tradition of passing knowledge and culture from generation to generation. After European contact and the attempt to assimilate First Nations people into Western culture, much of the language and other vital information held by the elders was nearly lost. But the elders, many of whom are now gone, relied on the strength of their oral traditions, and worked tirelessly with the youngsters to transfer the information to the next generation. "This painting," says Susan Point, "is dedicated to the elders of my community who instilled within us the values and traditions to ensure the younger generation's identity and voice. It is now the task of my generation," she adds, "to remember all that was taught and pass their knowledge and wisdom on to our children."

Point has created a visual representation of this valued educational process. The faces in *Salish Revival,* appearing in waves, create a web of community that continues through all time—a chorus of ancestors extending back countless generations. A sense of urgency can be seen in the round, open mouths of the faces as they try to communicate. "This canvas depicts many peoples connected to each other in a common sea of humanity," Point explains. "All citizens of the earth have their own unique histories. Central in this painting, our voice is emerging proudly."

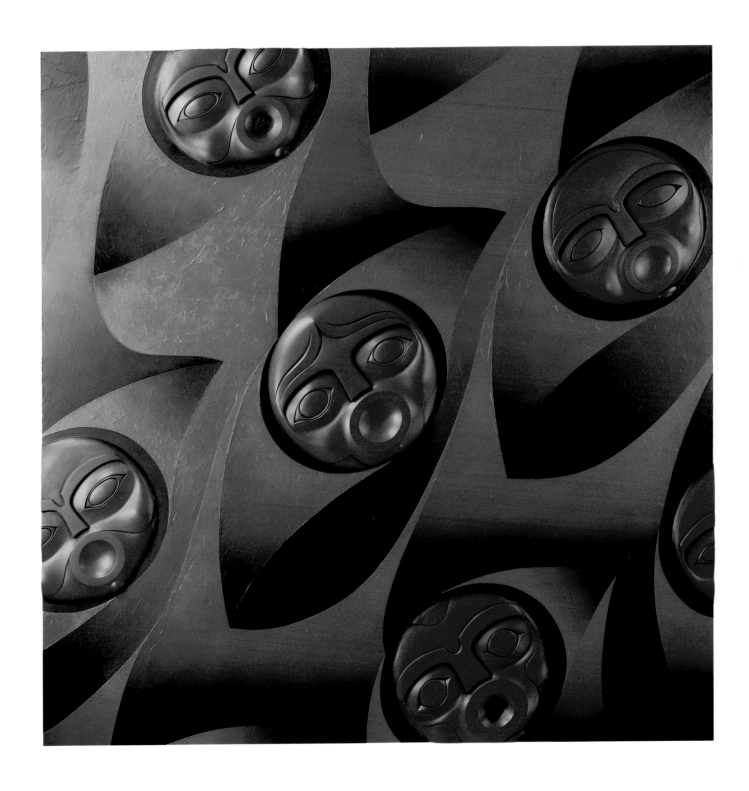

Salish Revival

2000 | acrylic paint, polymer, oil on canvas

6 feet × 6 feet × 6 inches

Changing Sea

This piece demonstrates that Susan Point is truly a contemporary artist whose deep stylistic roots are based in traditional Coast Salish design. *Changing Sea* could hardly be labelled a traditional Salish piece, yet the elements of line, form and mythology that define Salish imagery are hard to miss. The familiar characters, such as the salmon, the serpents and the killerwhale, provide the reassuring sense of history and home to this piece that links all of Susan Point's work.

Changing Sea consists of three carved, painted and laminated red cedar panels. Together, the three sections form a mural that is approximately 4.3 × 1.8 metres (14 feet by 6 feet). Each piece also carries a Salish weaving component.

In a style that Point calls "very contemporary and graphic in design," these panels each tell part of a story. The first panel features a design with four triangular salmon heads coming together within a sharp square. The second panel depicts a mythological two-headed serpent. The third and final panel is of a killerwhale. The four small motifs in copper offer glimpses into the whale and her life's journey. In her dorsal fin are birds. In her eye is a sea serpent. The pectoral fin harbours fish, and in her tail is a baby.

"To me," Point says, "the set reflects the waters of the Pacific, woven into the lives of the Coast Salish peoples."

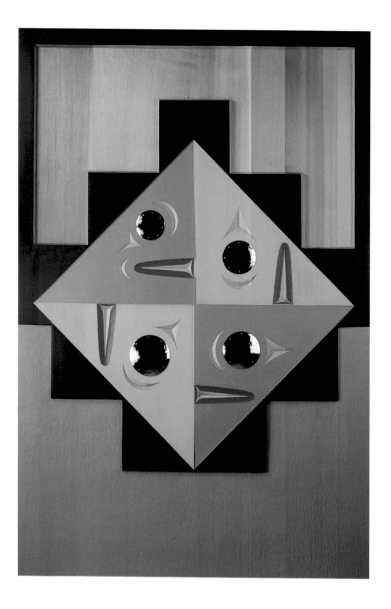

Changing Sea

set of three panels | 2000 | acrylic paint, red cedar, patinated copper, radium-coated copper | each panel 4 feet × 6 feet × 2 inches

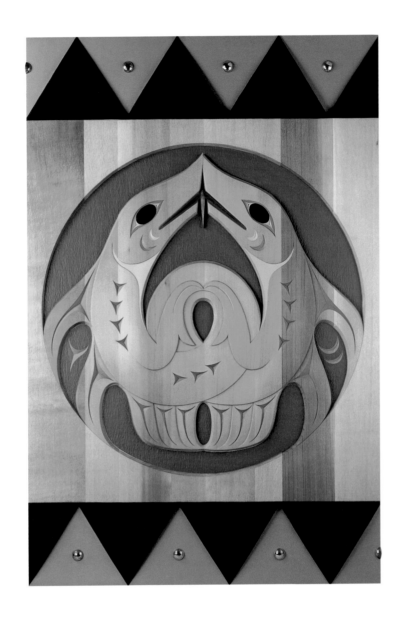

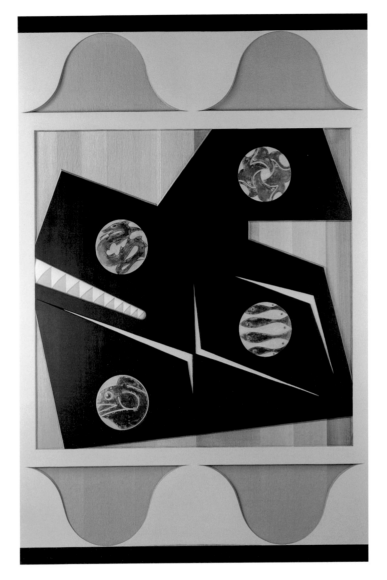

Skookumchuck Narrows

Skookumchuck Narrows, the West Coast body of water that inspired this intense, carved glass spindle whorl, is wild, dangerous and a magnet for thrill-seekers of all kinds. Located on the Sunshine Coast, at the entrance to Sechelt Inlet, this tiny section of water, known by locals as "the chuck," is a remarkable example of nature's version of extreme engineering. Every six hours, the unstoppable swell of the ocean tide attempts to push in through the narrow, rock-walled inlet, slamming straight into water thrusting in the opposite direction as it seeks to escape from the inlet. The result is a torrent of eddies and whitewater that has claimed the lives of numerous kayakers and other adventure-lovers over the years.

Because Susan Point and her family enjoy thrills, Skookumchuck Narrows is a favourite getaway spot. She explains, "We often challenge the narrows with our jet skis. It's often terrifying." The area also provides many quieter activities that the family equally enjoys. They fish, gather oysters and clams, and explore the immense beauty of the region, taking trips, by boat or jet ski, into Princess Louisa Inlet. "The inside inlets [Narrows Inlet, Salmon Inlet, Sechelt Inlet]," Point marvels, "are sometimes dead calm on the inside and small seal colonies and beautiful camping spots are found there."

The design of *Skookumchuck Narrows* accurately reflects the exhilaration that comes from encountering the wildest forces of nature. The central design, two sharks swimming in opposite directions, are included in the piece, because mud sharks, or dogfish, are often caught by the family when fishing. Surrounding the sharks are cresting whitewater waves and deep eddies or whirlpools, which are symbolized as smaller whorls with their centre holes completely piercing the glass. The overall effect, is heart-stopping.

Skookumchuck Narrows
2000 | patinated carved glass, red oak | edition of 2
24 inches in diameter | granite base 32 inches in diameter

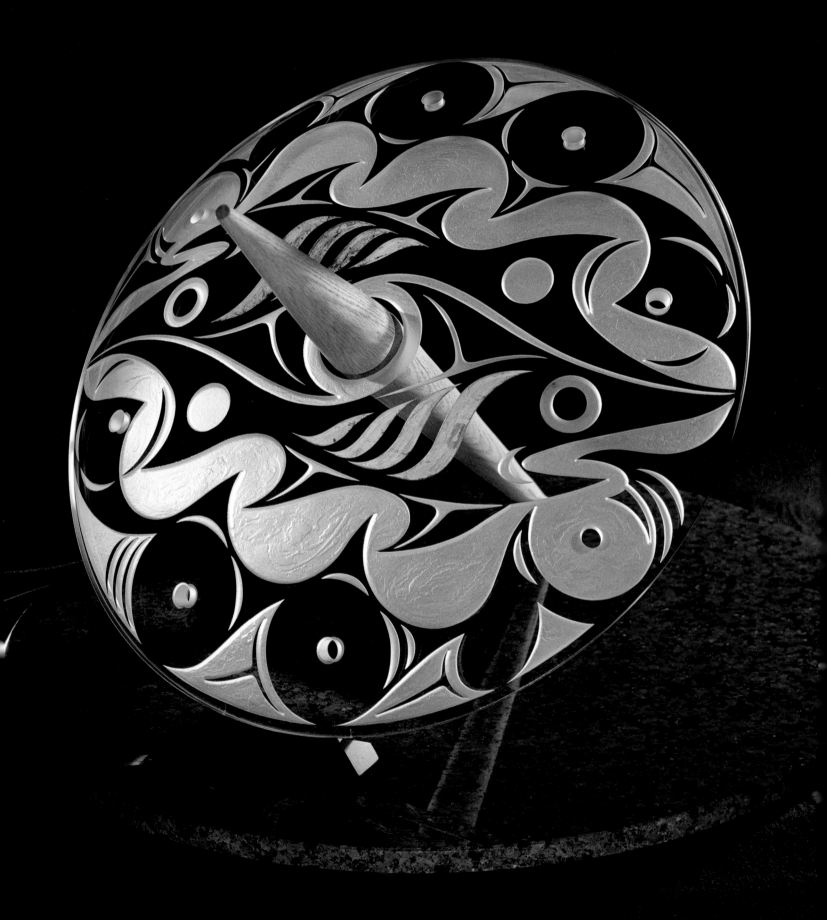

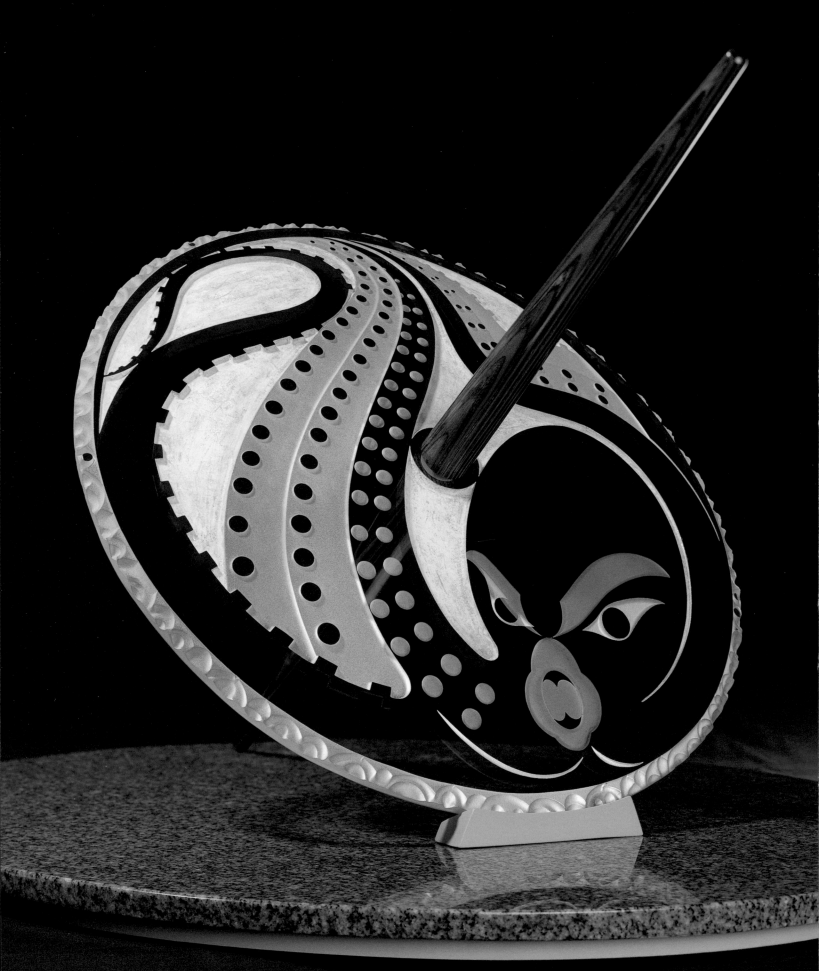

Deep Retreat

The mysterious and fascinating octopus, well known to native fishermen, is a watcher. Hiding in cracks and crevices that mark the undersea world of the West Coast, we only ever see them when we become watchers ourselves.

Deep Retreat
2000 | patinated carved glass, multicoloured laminated wood
21 inches in diameter | granite base 30 inches in diameter

Four Elements is a fascinating sculpture that inspires viewers to look beneath the surface for what lies below. Each of the four elements depicted—water, earth, fire and wind—is illustrated by a glass spindle whorl. On the top of each whorl is an image representing that element, yet deeper in the sculpture lurk surprises.

The element of water is illustrated by ripples, portrayed in frosted glass, emanating from the point where a drop of water must have fallen. Underneath the ripples, salmon appear to swim in and out of view. Earth is represented in the lumbering footsteps of the great grizzly bear, making its way over the textured glass terrain of the second whorl that is created by a method of kiln-casting the glass. Far below, still and quiet, lie Salish artifacts embossed on the underside of

the whorl. Fire has left its mark on the third whorl. The flames scorching the top of the piece have consumed what is in their path, leaving a smooth surface created through a technique of fire-polishing the glass. Finally, the wind is marked by deep relief lines sculpted into the glass to yield the effect of erosion, which reveals the silhouette of an eagle's head.

Each of the four glass whorls is created in a soft-squared format using different woods for the spindles. To highlight the variation between the elements, Point has chosen four very different woods. Oak and walnut are accompanied by purple heart, a hard, brownish wood native to South America that turns purple when the inside is exposed to air, and padouk, a wood resembling rosewood that is native to Africa and Asia. The entire sculpture rests on a striking, highly polished marble base.

Four Elements is significant for Susan Point for several reasons. The number four is symbolic for many cultural groups, especially First Nations, because it represents the four directions, four seasons, four corners of the earth, four great races and, as we see here, the four elements.

On another level, *Four Elements* reflects Point's personal relationship to nature and the four elements. "No artist," she says, "can ever equal the beauty found in nature. I love the outdoors, and hike and camp whenever I can. This piece, *Four Elements*, is contemporary and leaves the viewer with the challenge of connecting the elements to the motifs in glass."

Four Elements
(Earth, Wind, Fire and Water: set of four) | pages 64, 65, 66 and 67
2000 | carved, fire-polished and cast glass | edition of 10
each 10 × 10 inches (approx.) | marble base 32 inches in diameter | spindles of oak, walnut, purple heart and padouk

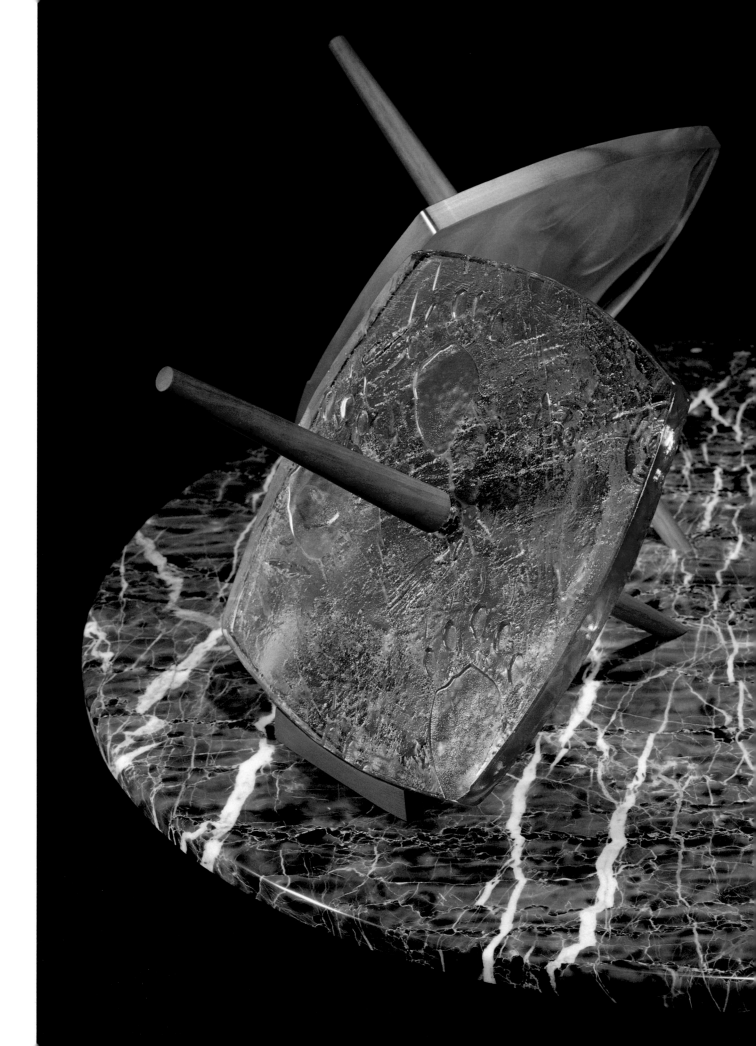

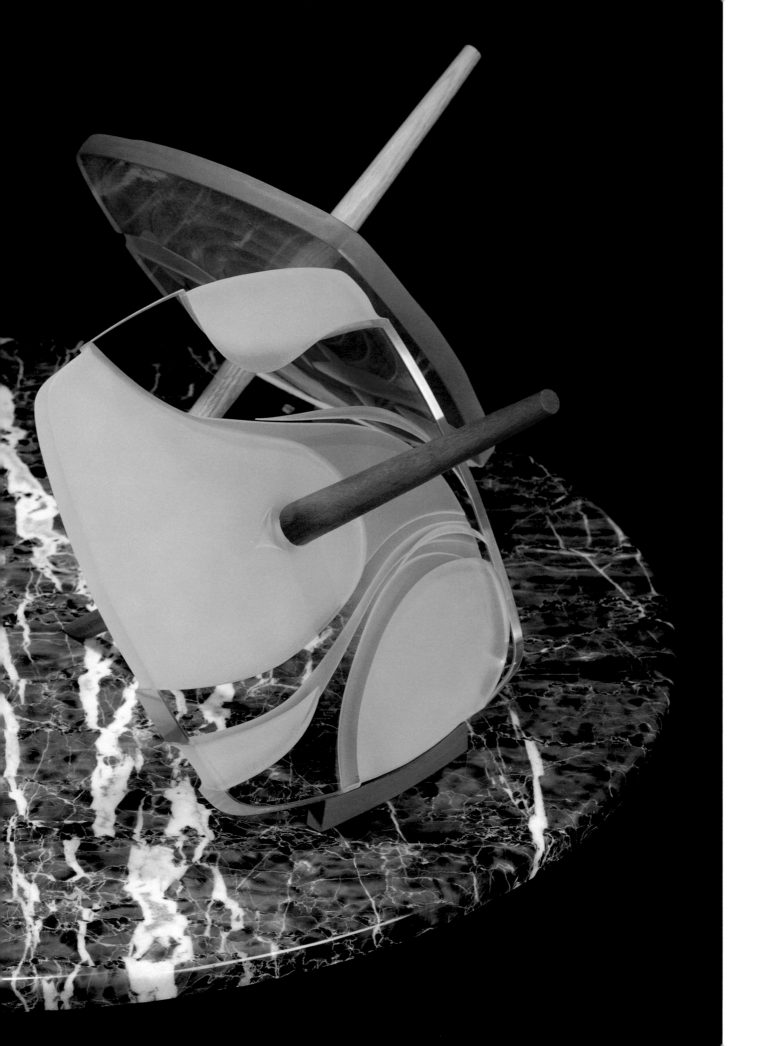

Triumphant Return

After four years of freedom and struggle in the open Pacific Ocean, salmon, in numbers too great to imagine, make the long journey inland to the rivers and rocky stream beds where their odyssey first began. As they reach their destination, they will spawn, beginning the cycle for a new generation, and then eventually die. Along the way, their bodies become more and more red in colour. When the large, dramatic salmon runs happen every fourth year, spawning grounds, like the Adams River in B.C.'s interior, become a carpet of deep, undulating red.

For Susan Point, this stylistic wall sculpture celebrates the salmon's cycle of life. Carved from red cedar, this piece has been painted to highlight the increasingly red colour of the salmon as they prepare to spawn. It was inspired by a style found on a historic carved Salish panel Point has always admired at the University of British Columbia Museum of Anthropology.

"I guess the title of this piece speaks for itself," Point explains, "because nowadays, with all the added obstacles fronting the salmon's path (man-made or natural), it is indeed a triumph when they return."

Triumphant Return
2000 | acrylic paint, red cedar
4 feet 5 inches × 4 feet × 4 inches

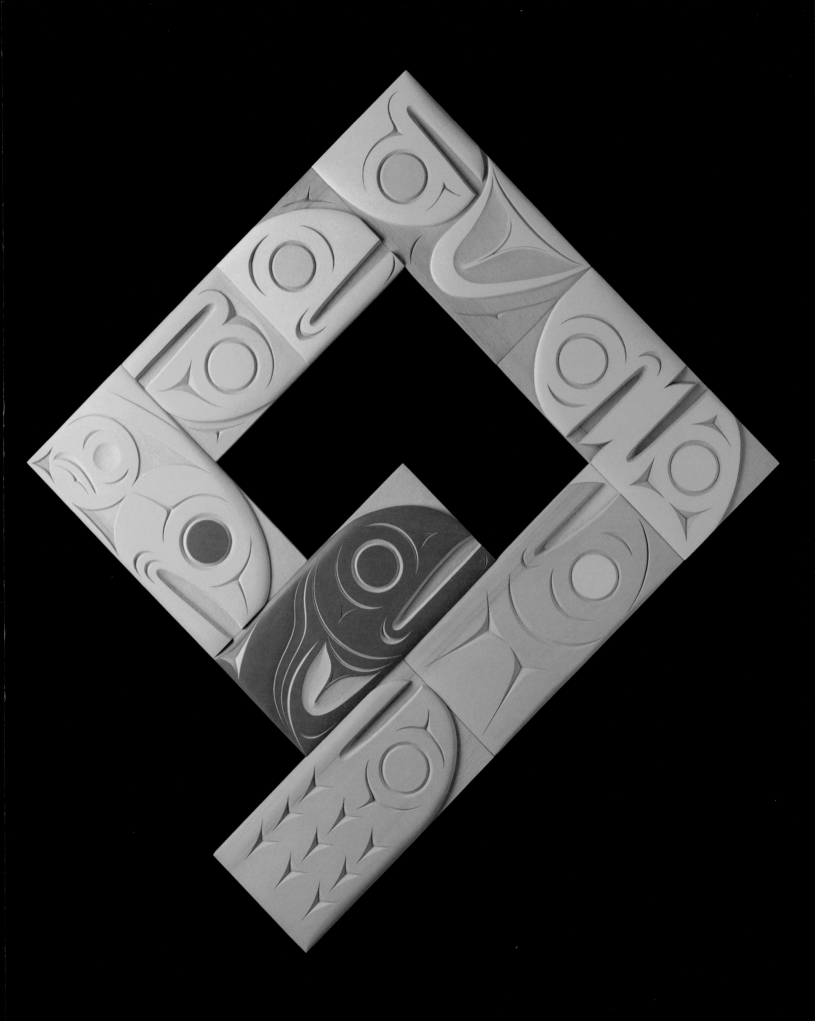

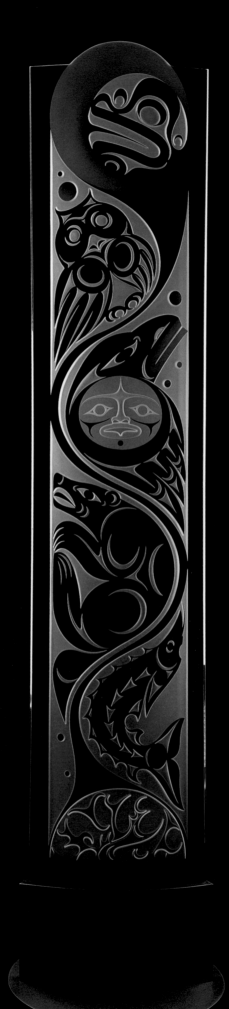

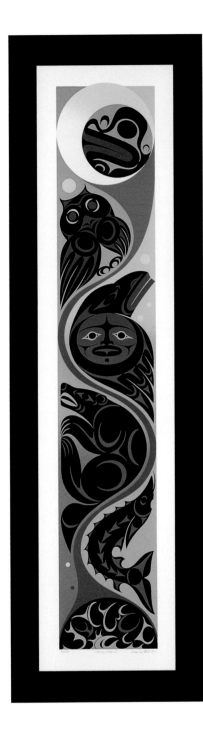

The scope of life on earth encompasses a vast space, with the moon and the centre of the earth as its borders. This space is our playground. Within this clearly defined area live creatures who spend their entire lives in one part of this environment or another. Most likely, they carry no awareness of the others they share this space with.

In *Common Thread*, a 2.1-m (7-foot) glass house post and a limited edition serigraph, Susan Point illustrates the link between all creatures. "I believe," she states, "all life on earth, and no doubt the universe, is connected." This piece relates to our own planet and also includes a few celestial bodies, a practice not uncommon to traditional Salish house post design.

The top of the post features the moon. Its face is that of the wolf—a creature we often associate with lunar events. As the most distant object we as humans have been able to reach, the moon keeps watch at the outer reach of our existence. Directly below the moon is a star, and a few other stars appear throughout the piece. Below the star sits the owl, a messenger. Farther down, at the halfway point, the raven makes an appearance. The raven features a human face, belying its reputation as a transformer, moving between one form and another. Next is a wolverine, and then a sturgeon—known for living on the deep sandy bottom of the river. The earth, anchor or root of this piece, is fiery and wild to the core.

Connecting all of these creatures, whether they know it or not, weaves the thread, the river of life—that which reminds us we are all related.

Common Thread
above | 2000 | ink, paper | edition of 52 | 30 × 12 inches

Common Thread
facing page | 2000 | carved and kiln-formed glass
88 × 18 inches | stainless steel base 28 × 18 × 24 inches (approx.)

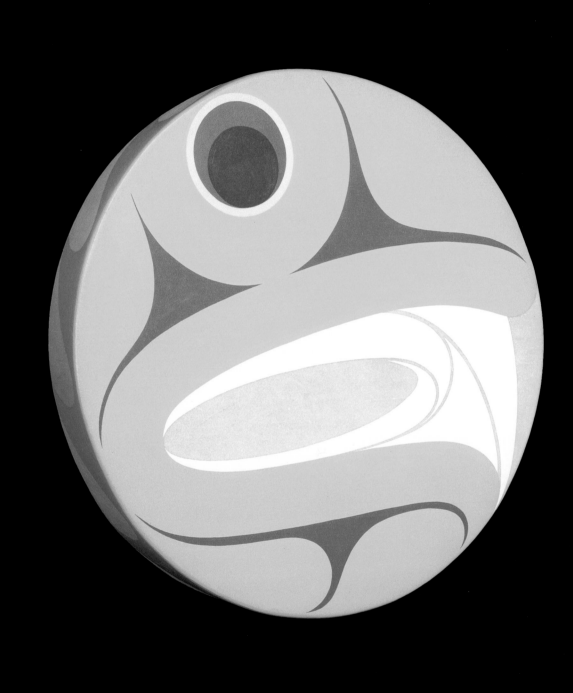

In countless cultures around the world, the beating of a drum creates a powerful statement. In First Nations cultures, the drum is a vital member of the community and can be heard across vast expanses of land and water. The regular pulse of a drum brings people together, if only for a moment, into a common, focussed rhythm.

For First Nations people, drums bring a sense of joy and exuberance to ceremonial potlatch celebrations, which pay tribute to the rich traditions of the people. "The sound of the drum, the heartbeat of our people," Susan Point explains, "brings meaning and life to our gatherings." In many ways, drums become characters as stories are passed from one generation to the next.

Point has given these three drums individual names—*Red Snapper*, *Encounter* and *Sister Wolf*. Drums are always different, and the rawhide stretched over the wooden frame can vary, even slightly, in thickness or strength, giving each drum a distinct sound or voice. Unlike many of Susan Point's other pieces, the design of the drum doesn't tell a story. Instead, it creates a character. It is the function of the drum, when used in a ceremony, to contribute to the oral history passed down to the children.

Red Snapper
2000 | rawhide, red cedar | 24 inches in diameter × 4 inches
mahogany base 4 × 4 × 30 inches

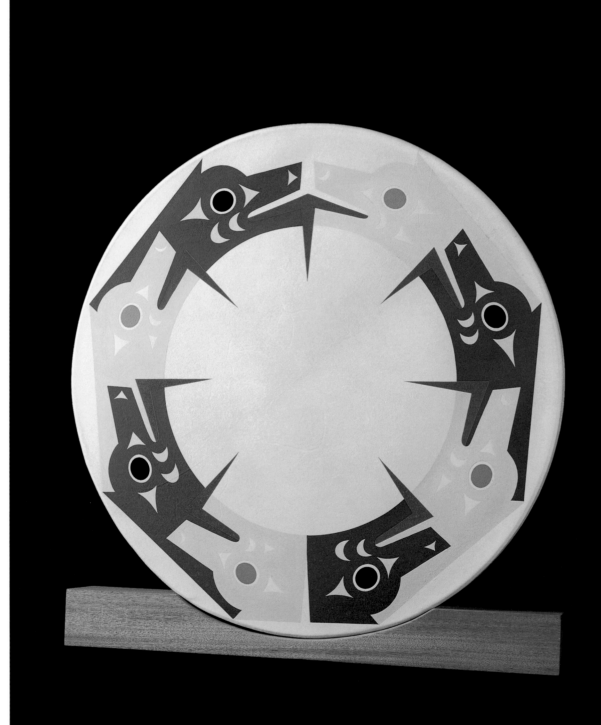

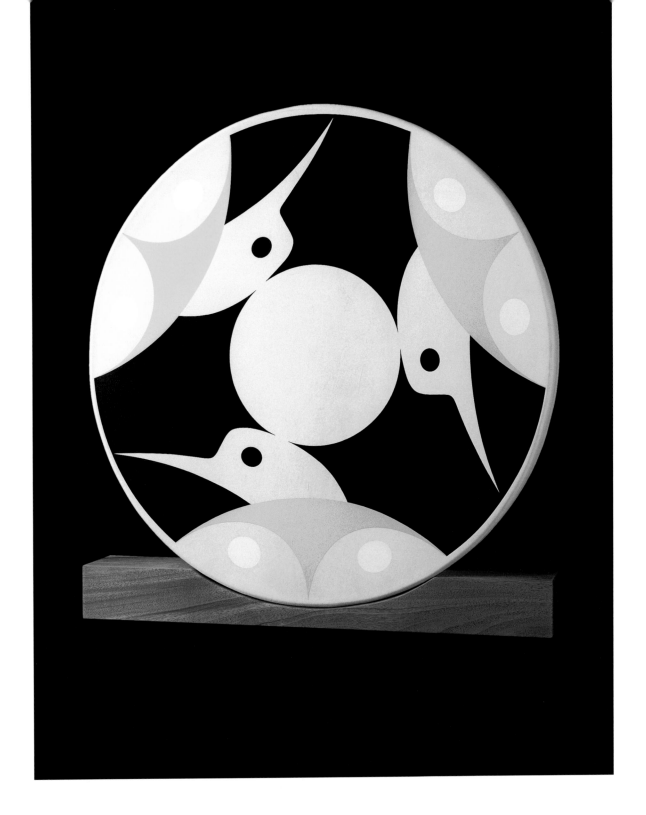

Encounter
above | 2000 | rawhide | 30 inches in diameter × 4 inches
mahogany base 4 × 4 × 30 inches

Sister Wolf
facing page | 2000 | rawhide | 30 inches in diameter × 4 inches
mahogany base 4 × 4 × 30 inches

The task of my generation

is to remember *all that was taught,*

and pass that knowledge and wisdom

on to our children.

—SUSAN POINT

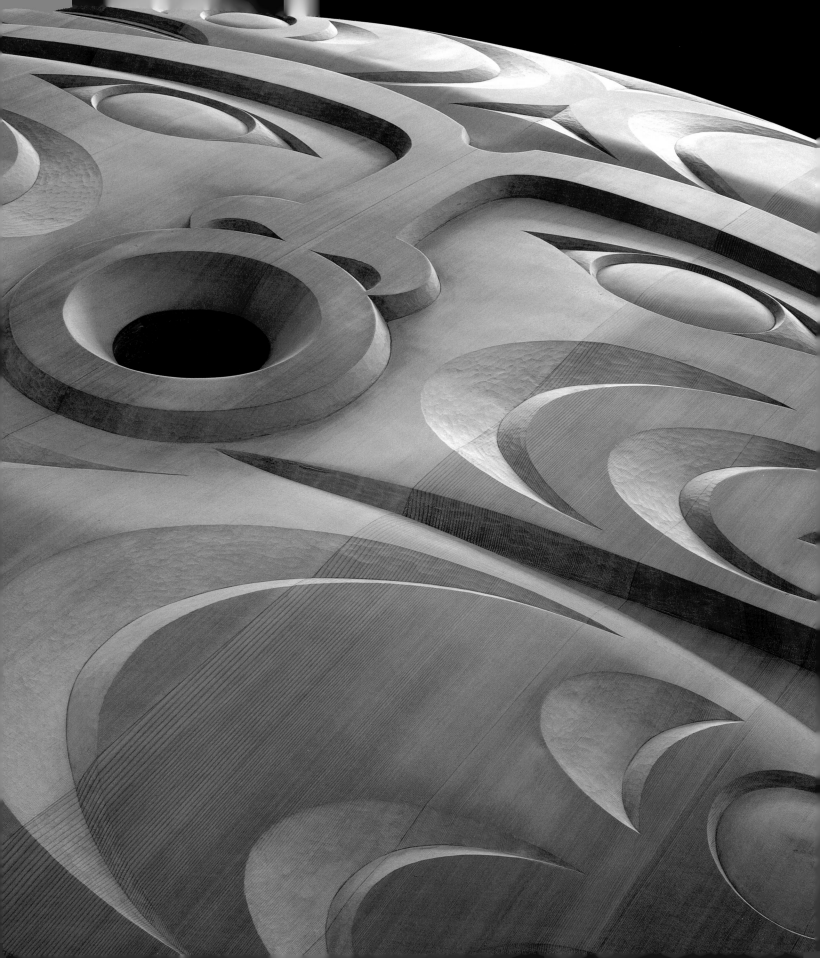

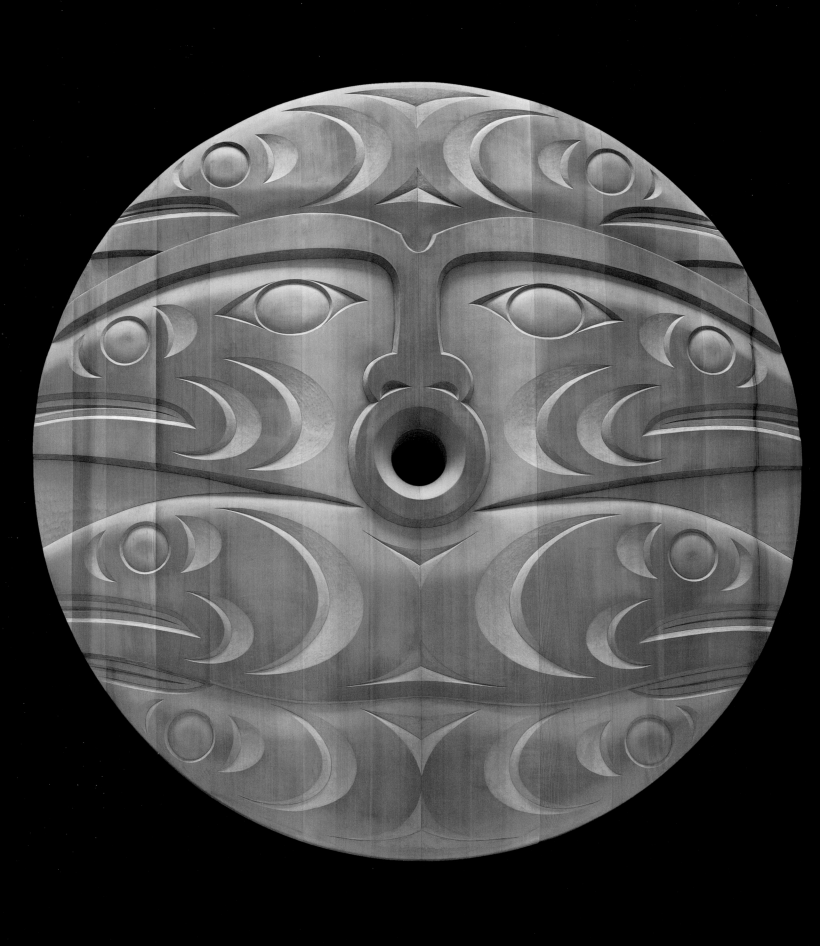

"I've re-created this image from an old classic spindle whorl," Susan Point explains. "I love to create new and contemporary imagery in my interpretation of Coast Salish style, but every so often I need to pay tribute to classical design—to grab on to the roots of my beginnings."

As an artist, Susan Point has moved from the role of the apprentice to that of the teacher, and her works of art have grown from tiny pieces of elaborate jewellery to monumental installations. *Point of Origin* is a 2.1-m (7-foot) laminated spindle whorl carved out of red cedar featuring a school of salmon and a human form at its core. Based on a much smaller traditional whorl from centuries ago, this larger piece is perhaps a monument to the inception of Point's artistic path, the origin of her education as an artist and the grand scale to which she has taken her ideas.

Point of Origin

2000 | red cedar | 7 feet in diameter × 6 inches

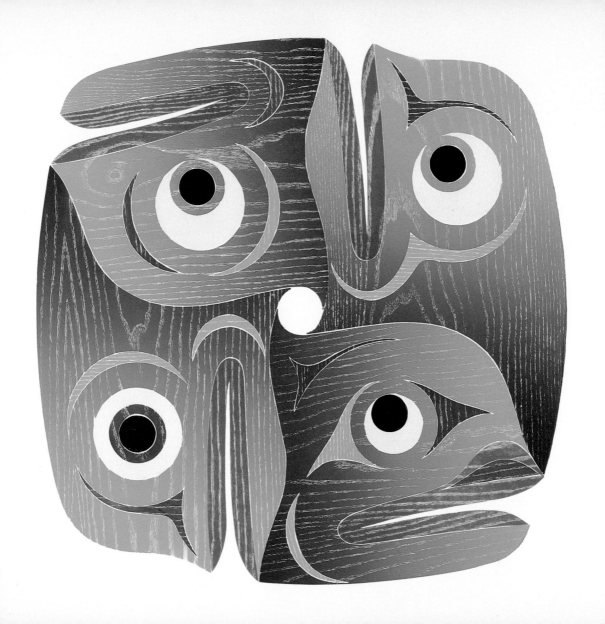

In the time before European contact, the Coast Salish, like most First Nations peoples, were guided through the seasons by signs in nature. A rhythm was created—a cycle that led to a harmonious existence between the people and their environment.

For the Coast Salish, spring was a time for hunting and fishing. The hot and dry time of summer was dedicated to gathering berries, shellfish and cattails for weaving mats. By late autumn, as the leaves turned and the days began to grow shorter, a particular sign heralded the time for people to move indoors and return to the longhouses for the Winter Ceremony. This sign, one that many of us would never notice, was of great importance to the Coast Salish. To know winter was approaching, one had only to listen for "when the frogs stopped singing."

In winter, the sacred ritual of spirit dancing took centre stage. Feasting, the bestowing of gifts, and telling the stories that passed on vital cultural history and values became a daily focus.

The yearly cycle began again in early spring, when all the gifts of the winter, like food, elaborate blankets, had gratefully been given away. The time to leave the longhouses and once again live outdoors was marked by a joyous sound—"when the frogs started singing again."

In countless First Nations groups, the frog is the voice of the people. It symbolizes innocence, stability and communication. Even in these times of technology and the invasion of sounds like airplanes, traffic and sirens, the return of the frogs and their song was a welcome relief for Susan Point as she emerged from winter on the Musqueam reserve in Vancouver. "Each year," she recalls fondly, "I would hear thousands of frogs singing and croaking around my house." Now, the eagerly awaited spring brings a moment of sorrow for Susan Point.

As housing developments pushed farther toward her home, the frogs were forced away. First they moved west, but if she tried, Susan Point could still hear them. In the last two springs, their song has nearly been silenced. The frogs are now trying to survive on a plot of land on the far west side of the reserve. But this too has been designated for development. As the title for this piece suggests, the frogs now have nowhere left to go.

For many people, the childhood memory of holding a frog on the palm of your hand is vivid. Its fragility was overwhelming. It could sit on the palm of your hand, and, looking close, you could see its delicate bones and smooth skin. You couldn't put your hand on its back, or you might hurt it. Cupping your hand over top would keep it from hopping away—at least for a moment. Fragile—it's a word that can't even pretend to touch on the vulnerable nature of these wonderful ambassadors of the seasons. In environmental circles, the frog is metaphorically considered the "canary in the coal mine"—its silence heralding not the onset of winter, but the first physical signs that the environment is fast becoming a poisonous tomb for all of us. Frogs are highly susceptible to the damages brought on by pesticides, fertilizers, habitat destruction and ozone depletion. The world's amphibian populations are disappearing at an alarming rate. So few of us have been trained, by generations of culture, to listen for their song, that we have not noticed their silent warnings until only recently. "It seems," Point laments, "that the voice of the frog is being silenced and we are losing our connection to the land."

Susan Point's limited edition puzzle woodblock print *Nowhere Left* illustrates the importance of the frog in our survival. Although the overall image of these puzzle pieces was designed as a soft-squared spindle whorl, we can't help but notice how devastating it would be to the design if just one of the four frogs was missing from the puzzle. The number four is significant in First Nations culture, relating to the four winds, the four seasons, the four directions and the four corners of the earth. These frogs are each different, and the one in the lower right corner looks almost human, relating, as Point says, to our own connection to the earth and the environment.

What will happen to us when the song of the frog is silenced forever? How will we know when to return outdoors in the spring? Will winter ever end?

Nowhere Left
2000 | ink, paper (a puzzle woodblock print)
edition of 44 | 30 × 30 inches

Good Luck

In First Nations tradition, the salmon, once so abundant off the West Coast, is believed to be the giver of life. As indicators of wealth, and the cycle of life, the fish are usually carved in pairs for good luck. As the salmon are now threatened, we as a society are only now realizing how lucky we are that they have survived this long. This image, titled *Good Luck*, illustrates traditional Salish carving style. Although it is an original Susan Point design, it is highly classical in nature.

Perhaps more than any other artistic method, the process of creating a reduction woodcut such as this one is as fascinating as the final outcome and requires a bit of luck on the part of the carver. In *Good Luck*, the full circle in the spindle whorl was printed first in a light tone of red. The central area between the two salmon, in this instance, was then carved away, and what remained was printed in a slightly darker shade of red. Finally, all the elements within the two salmon were removed, and the last uncarved areas were printed using a third, darker shade of red. For each colour, the wood plate is inked on the surface, revealing a relief image or texture. Any of the cuts, gouge marks or indentations from the carving process do not appear. Because each previous level is destroyed by the next, there is no chance to go back and make corrections in this process.

Good Luck

2000 | ink, paper (a reduction woodcut print)
edition of 30 | 30 × 30 inches

Paddles

Paddles for canoes perform an obvious function: they are the means of propulsion as a person or group moves from one water-bound location to the next for hunting and travel. In this manner, they become the means for a journey through rivers and oceans.

Each of these paddles by Susan Point has its own journey theme. *Homecoming* depicts the triumphant return of the salmon as their journey ends at the same spawning grounds where it began four years earlier. The other side of the paddle, though, shows the salmon in a more abstract form, possibly indicating that the future of the salmon is not as clear as we would hope. This paddle, made of yellow cedar, is free-standing in a base made of mahogany. The tip, or blade, of the paddle points up. When a canoe arrives in a foreign village, the paddlers traditionally rest their paddles in this position. Each paddle is presented to those on shore as a gesture of peace and goodwill. Then, after asking permission, the paddlers manoeuvre the canoe onto the beach stern first, a further symbol of the peaceful intentions of those in the boat.

Homecoming
right | 2000 | acrylic paint, yellow cedar | 5 feet × 6 inches × 2 inches
cherrywood base 24 × 24 inches

To the Potlatch
far right | 2000 | acrylic paint, yellow cedar | 6 feet × 11 inches × 2 inches
mahogany base 32 × 16 inches

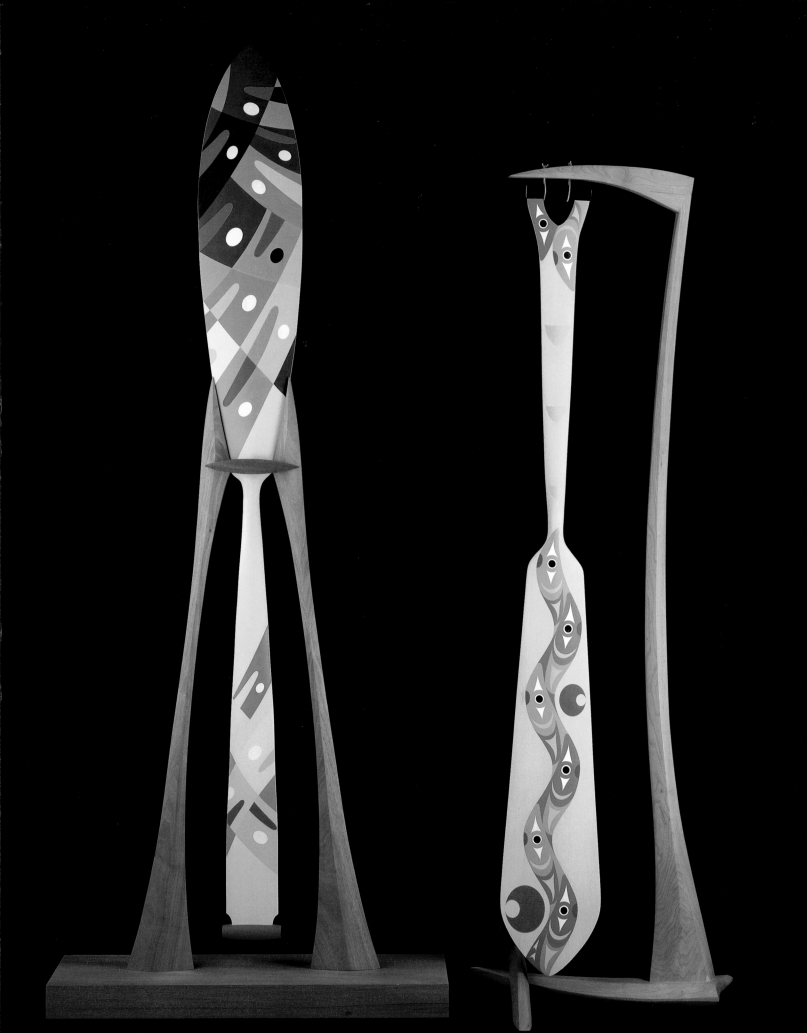

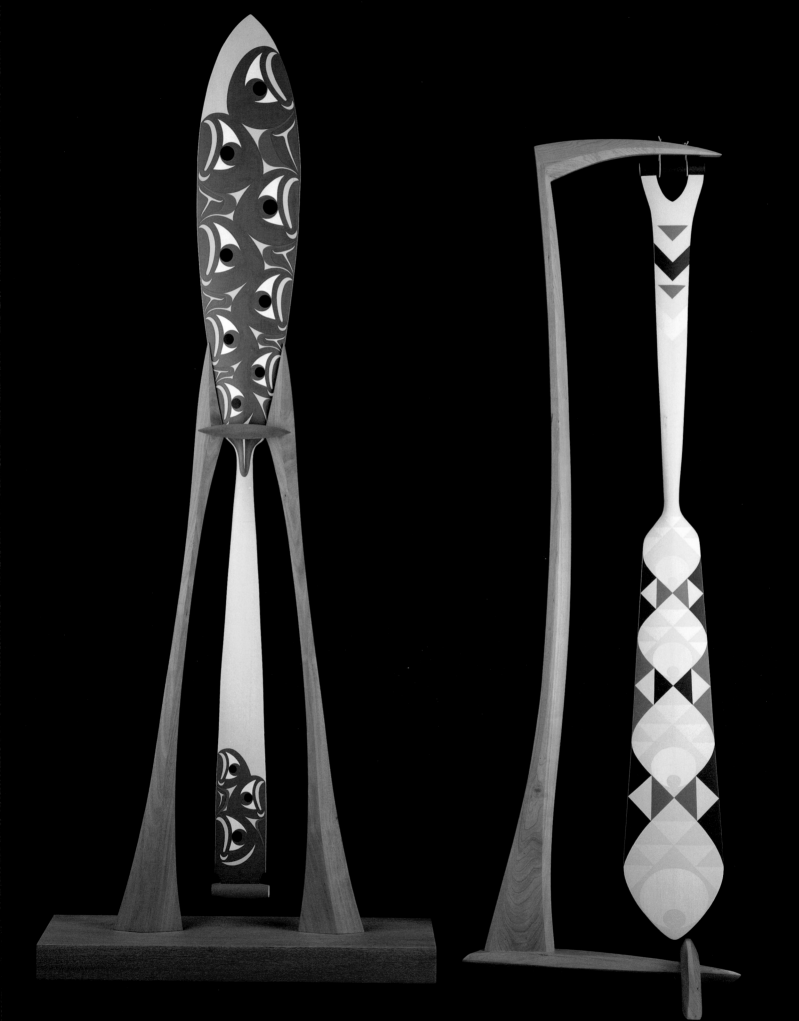

Susan Point's second paddle, *To the Potlatch*, features a human element, and the blade is pointed down as it sits in a cherrywood stand. Positioned as it would be in the water, this paddle is set to propel humanity on the journey toward the future.

Homecoming
far left | 2000 | acrylic paint, yellow cedar | 5 feet × 6 inches × 2 inches
cherrywood base 24 × 24 inches

To the Potlatch
left | 2000 | acrylic paint, yellow cedar | 6 feet × 11 inches × 2 inches
mahogany base 32 × 16 inches

Inukshuk

Balanced and calm, this glass sculpture almost appears to be lit from within, harbouring a power source all of its own. Titled *Inukshuk*, the sculpture represents the Inukshuks, or carefully piled rock sculptures that act as place markers and symbols of welcome for Canada's Inuit people. This particular collection of glass rocks has already played a starring role in a major event in Canada's recent history.

When the new territory of Nunavut was established on April 1, 1999, Canada Post commissioned a commemorative stamp and "Day of Issue" envelope to celebrate the occasion. The artist they chose to create these works was Susan Point.

When a new stamp is issued for a special event, a commemorative printed envelope and cancellation stamp (the ink stamp indicating the postage

stamp cannot be used again) are created as well. An image of this Inukshuk highlights the envelope, acting as an introduction for the postage stamp.

Susan Point's stamp to honour the creation of Nunavut features Inuit children in a multimedia illustration. At the time of the celebration, she wrote:

"In creating the illustration for the commemorative stamp on the subject of the Nunavut, I wanted to show the Inuit's strong presence by incorporating the warm, friendly faces of Inuit children across the horizon; the young faces of the Inuit representing the future generations who will look over this great new territory. As well, I wanted to show the large land-base settlement of the Inuit by giving depth to the landscape. Shown here is a new dawn on the land; a springtime setting with the snow just melting representing a new beginning. I have

also included an Inukshuk on the horizon as well as in the foreground; the Inukshuks representing guidance, comfort and welcome."

Now that the speeches and the ceremonies are over and life in the north has returned to normal, this silent, magnificent glass sculpture continues the task it was created for: marking a time and a place, watching over the children of Nunavut and offering welcome.

Inukshuk

1998 | acid-etched carved glass (with first-day-issue stamp)
14 × 12 × 6 inches

88.

Looking Forward

Susan Point's mesmerizing *Looking Forward* was inspired by a spindle whorl discovered in the Fraser Canyon area above Yale. Believed to have been created around 800 A.D., the original piece was carved out of steatite, a stone native to the area. Point has brought her own style to the piece, which features an eddy of eyes emanating from the centre where the spindle attaches. If this piece were to be spun, as the original must have been, the effect would be both dizzying and exhilarating at the same time.

In much of Point's work, the eyes in both humans and animals are the same, making the nature of the creature(s) in this piece a carefully placed mystery. Is it humanity looking forward? Is it nature assessing the future of humanity? Does it matter? The only meaning Point will reveal is that the piece represents "looking toward our future."

For Susan Point, a piece begins with a thought, but the process of creating the piece to where she is happy with the outcome allows for that original thought to evolve along with the meaning. "So," she explains, "some pieces that I do have more than one meaning to me." In the end, though, the individuals who view any work of art must come to their own understanding of what a piece means to them.

Looking Forward
2000 | patinated carved glass, multicoloured laminated wood
21 inches in diameter | granite base 30 inches in diameter

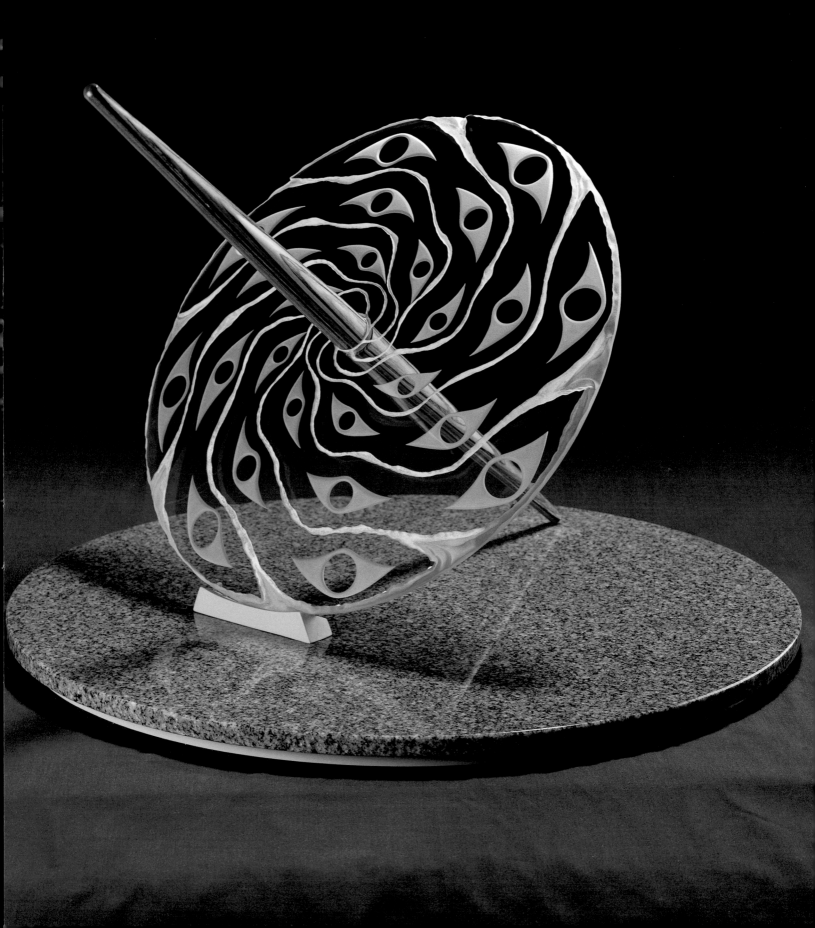

Four Corners

Celebrating multicultural diversity from the four corners of the earth, Susan Point's *Four Corners* reflects how all races and cultures, though extremely diverse in politics, beliefs and customs, are derived from the same root or foundation. When all of these differences come together, the result is both challenging and exciting.

A larger, monumental version of this piece, located at North Seattle Community College, has already been described by Peter Macnair in his opening essay. When Point was invited to create this larger piece, she was impressed by the cultural diversity among the students on the campus. She discovered that the campus was built on a site with a great deal of significance for the Coast Salish people of that area. Licton Springs, on

the border of the campus, is red in colour as a result of the spring water passing through dark red clay. The clay was revered as a pigment used in ceremony and decoration. Later, Europeans used the springs for therapeutic bathing.

This smaller, four-panelled artist's maquette, or model, from the original demonstrates the four basic elements of the larger piece. *Four Corners*, cast in a polymer resin, has been painted with rich oil colours to bring the faces to life. The facial designs are precisely aligned, allowing the tops and bottoms

to be combined in any number of ways. Each piece highlights slightly different ethnic facial characteristics. The terra cotta–coloured wave pattern in the background, referring to the springs, is also precisely aligned, yielding new patterns with every different arrangement of the pieces.

In the larger piece in Seattle, all possible options for arranging the sections have been laid out for the viewer—a tribute to the great wealth of diversity the students are blessed with on a day-to-day basis. Looking at this smaller, highly focussed piece, we can see how closely we are all linked, and how much potential there is when we come together as a community.

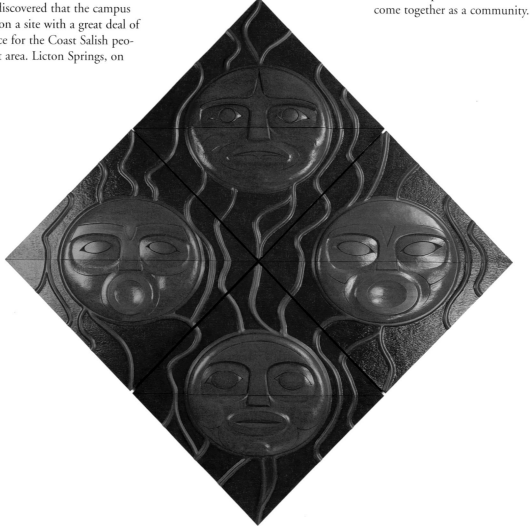

Four Corners

2000 | oil paint, cast pigmented polymer

10 feet × 10 feet × 6 inches

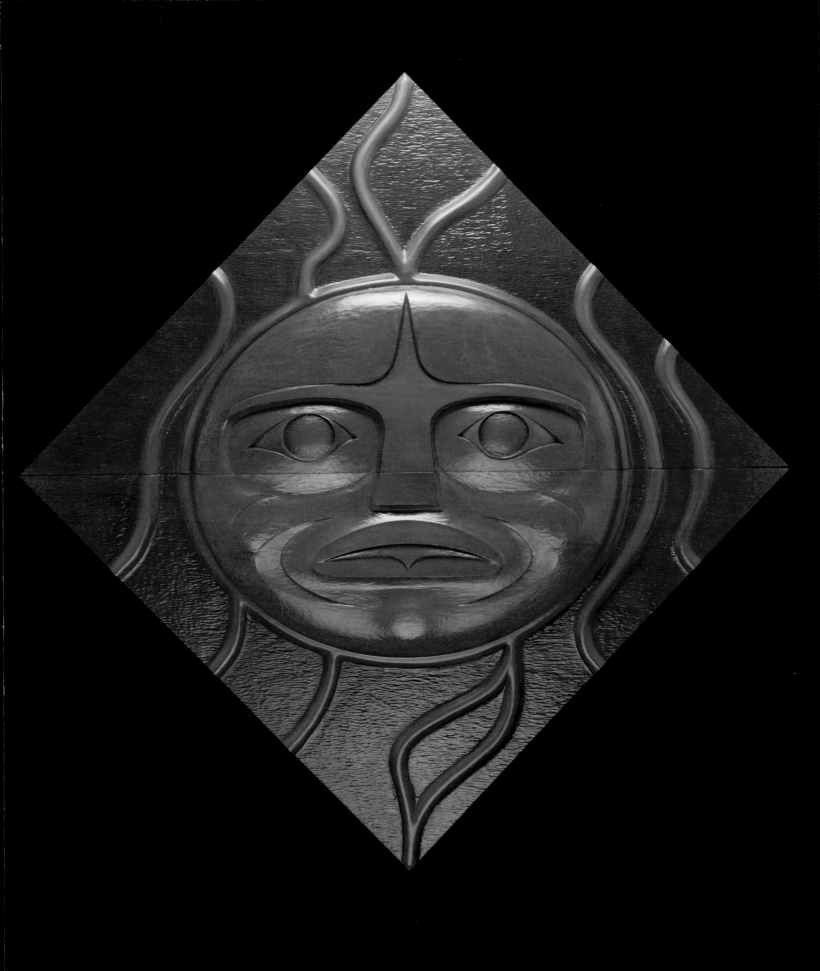

Contemporary Architectural Carvings

The present-day resurgence of art of the Northwest Coast has focussed on the northern style. In part, this resurgence has been somewhat market-driven by the "totem-pole image," the style of art portrayed and the public use of the work. The imagery created in the Coast Salish area, however, has traditionally been more personal in nature; the visual expression could itself embody and carry spiritual power. Coast Salish carvings were therefore less likely to be seen and understood—or even obtained—by outsiders. By the nineteenth century, the areas where Coast Salish art forms were centred also became some of the first areas of Euro-American settlement. Traditional objects were collected and sent to distant museums. The art and the architecture then quickly disappeared. With few exceptions, the shed-roof style of architecture distinctive to this area also disappeared before the arrival of photography on the coast, so little visual documentation exists. These historical changes, combined with the personal and private nature of the art form, led to heightened sensitivities surrounding the reinterpretation of the Coast Salish carving tradition as contemporary "art."

Susan A. Point's progress has been sensitive and deliberate in endeavoring to rekindle this complex art form to which she is heir. Since 1990, she has created large-scale works that draw on Coast Salish traditions of carving and architecture and integrate personal and communal forms of expression. One way to begin appreciating what Point has accomplished and continues to work toward in her large-scale architectural carvings is to understand the difference between the northern bighouse and the southern longhouse. The northern bighouse has a fixed footprint so that when the building is constructed, its volume is complete. In the past, the family would grow to the maximum capacity of the house and then either build a new house or disperse into new houses. The carvings, interior house posts and exterior "totem poles" most often carry crests that express broad family relationships and histories. The art is formalized in its character of production and is meant to be publicly viewed. The southern longhouse, by contrast, follows a modular form of construction that allowed families to expand their house through attached additions. The house consists of a structural frame of house posts embedded in the ground. The interior posts could be plain, carved in rounded shapes or carved with images expressing personal visions or respect for past ancestors. As the house posts are positioned against the wall, many have a flat, uncarved back. Their carved surfaces present images toward the interior of the house, where they would only be seen by the people inside. The house posts are connected to each other by means of a beam. On top of the beam sit the rafters, topped in turn by a roof made from long, cedar planks.

Susan Point's first large-scale works were produced in 1990 for the House of Hewhiwus, the Sechelt Band office and cultural centre. A two-module unit design of swimming salmon fabricated of wood was created for casting in concrete. When the cast modules were assembled, they created 929 square metres (10,000 square feet) of coverage for the exterior walls of the buildings. This commission and its application of large Salish-style motifs derived from small-scale engraved works in wood were a very public expression of Salish heritage.

Point's first house post (1991) was carved for the First Nations House of Learning at UBC. The building was inspired by Coast Salish architecture, and house posts in different tribal styles hold up the roof. The building's engineering requirements placed restrictions on the depth of cuts and amount of wood that could be removed to create the sculptural effects. Susan Point's 4-m (12-foot) house post, entitled *Raven with Spindle Whorl*, is carved in the round and supports a massive roof beam on its head.

The Vancouver International Airport arrival area houses three more of Point's works. An enormous spindle whorl, 5 metres (16 feet) in diameter,

The River
2000 | paint, red cedar, copper | 12.5 feet × 46 inches × 22 inches

greets arriving international passengers and makes them aware that they have come to the traditional lands of the Musqueam. The sculpture entitled *Flight* (1994) has two eagles with humans represented in the wings and salmon forming each human's body. At the base of an escalator are two more 5-m (17-foot) house posts (1996, 1997) carved in an elegant archaic Salish style and representing powerful images of the male and female ancestors of the Musqueam peoples. The back of these posts feature images of eagle heads carved in glass.

Susan Point has carved three house posts (1997) for the University of British Columbia Museum of Anthropology. The first is a male welcome figure located in front of the museum. Holding a fisher, the figure stands on a base carved with the image of a spindle whorl. Two bird heads and two hands with palms upraised are carved on the whorl as a sign of welcome. Above the head of the figure, celestial images are carved just beneath the channel-shaped notch that would hold a roof beam. The male figure holding a fisher is a motif seen in a number of nineteenth-century carvings, some of which now exist only in photographic form. In her interpretation, Point adapted this combination of elements in a manner that is respectful of the past but contemporary in form. The other two house posts at the museum are joined

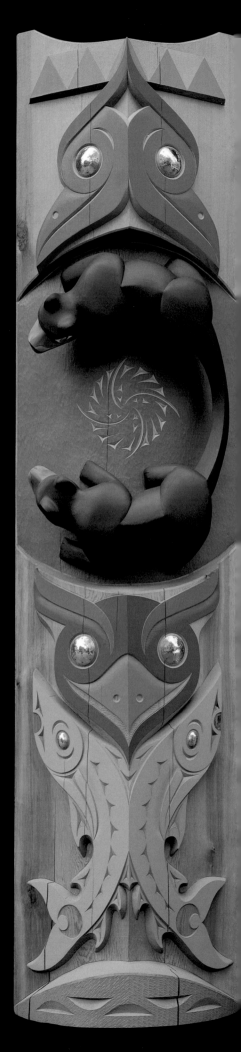

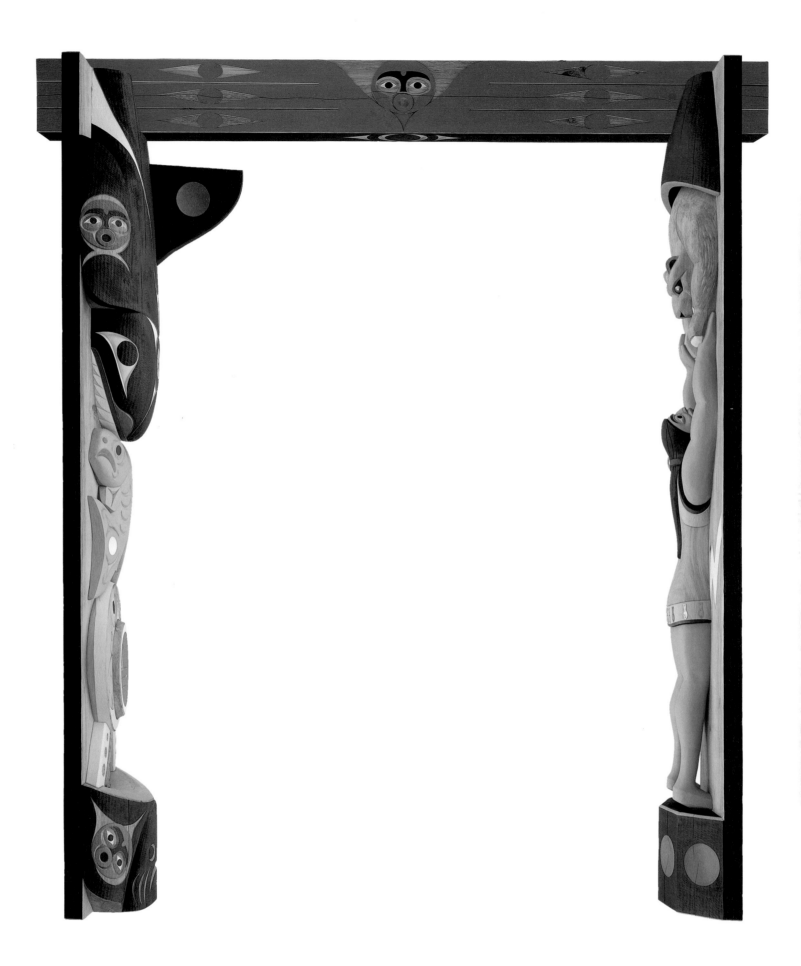

by a simplified house frame and act as a portal to the museum grounds, where northern carved totem poles and houses are displayed. This work was inspired by two nineteenth-century house posts from Musqueam, now in the American Museum of Natural History, New York. Point was careful not to copy the posts directly as they represent a family prerogative, but she gained inspiration from the old pieces to create images that carry new visual power.

Point has created three new house posts and a connecting beam for her major exhibition of new works (2000). They are contemporary works of art that respect past traditions while bringing a new vision and vitality to an ancient form.

The house post entitled *The River* represents life at the mouth of the north arm of the Fraser River. Life in and along the river is depicted through images of the once-plentiful sturgeon. The owl and heron heads represent the diversity of birdlife that the river supports. The powerfully animated fishers with copper eyes are links to wealth and spirituality from the past. The image on the central axis of the fishers, symbolizing the tide at the mouth of the Fraser, can

also be seen as four eagle heads. The base and top of the post illustrate weaving motifs, the base representing water, the top mountains and valleys.

Interaction consists of two posts connected with a crossbeam to form one structure. On one post, a woman stands on a base extending her arms and hands to the paws of a mountain lion emerging from a cave. The paws and hands symbolize the recognition and tolerance that animal and human have for each other. Between the woman and mountain lion, a copper dome mirrors their shared environment. The dome also reflects the house post immediately opposite. Point states that the human/animal relationship is a metaphor for the respect we must have for the world and our environment if we are to continue to survive.

Joining the two house posts is a connecting beam. In a longhouse, this beam would carry the rafters for the roof planks. As this is the highest point inside a house, celestial images are an appropriate embellishment. On one side of the beam is Xels, a being from the past who could fly and transform into any creature or object it wished. The other side of the beam features two eagles with a silver dome representing the full moon. Stars and a new moon adorn the top and bottom of the beam respectively.

The second house post is a complex representation from the ocean. A killerwhale looking down from the top of the post has its tail curled up at the base. Two salmon arc as if to avoid the mouth of the killerwhale and at the same time balance on the top edge of a disk representing the sun. The sun is life, and the salmon egg within the sun, new life. Two herring are carved on the outer ring of the sun; two containers of valuables carried by the sun are indicated by copper disks. The whale's tail at the base, carved with a shark's-head motif, is designed as a seat. It is the artist's intention that the individual who sits here completes the sculpture by connecting to the life cycle.

Susan Point's new works build on her understanding and presentation of an artistic heritage, which is both personal and worldly. For those with the opportunity to experience these works, each sculpture offers insights into the many metaphors of an ancient art form, commemorating past histories that are equally relevant for the present.

Interaction

2000 | paint, red cedar, copper, bronze, silver

17 × 4 × 15 feet

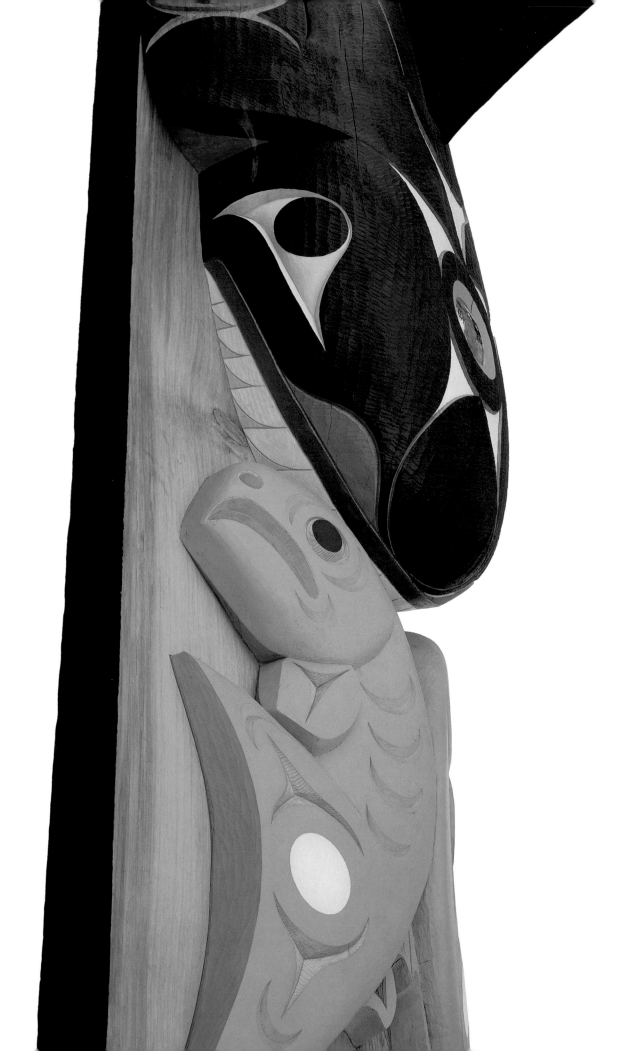

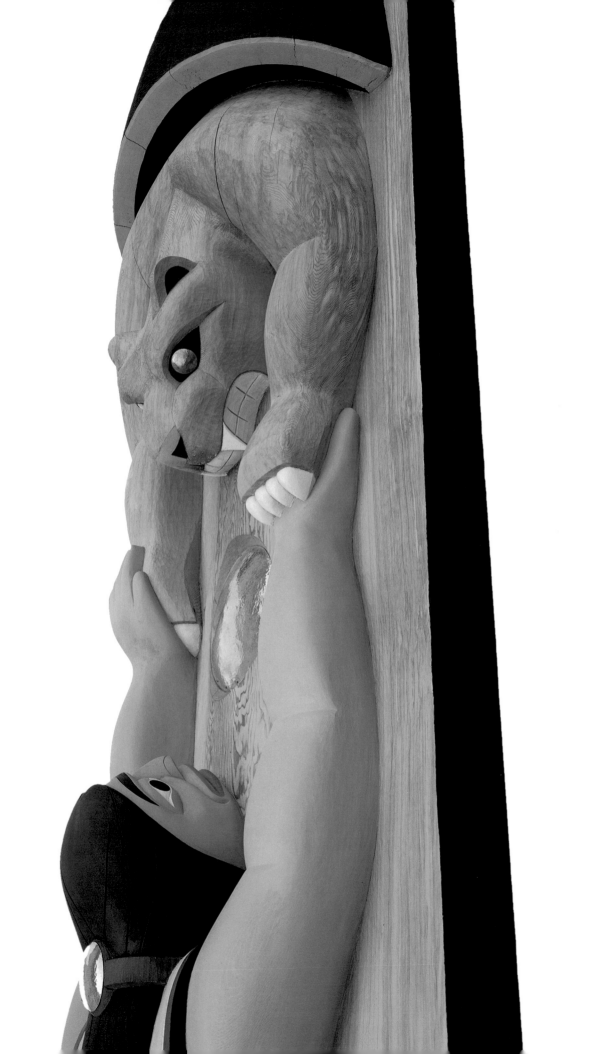

Camouflage

This is the life! A frog basking care-free on a lily pad. Not all of Susan Point's pieces delve into personal, political or social issues. Some, like this delightful piece, are just fun. For Point, this frog was not created for traditional or spiritual reasons, rather, as she states, "just because I love doing frogs." In keeping with the visual language of the Coast Salish that Point interprets so deftly, the frog in the philosophical sense just "is." "All I can do," she says, "is express my feelings and hope the viewer enjoys the piece for what it is." Frogs have played a significant role in Point's upbringing and knowledge of the world, acting as a vocal reminder of the turning of the seasons.

In a reversal of relationships, this piece, a mixture of glass and wood, is actually a pun. Instead of the lily pad providing camouflage for the croaking amphibian, here the oversized frog, carved in the shape of the lily pad, provides camouflage. Subtly carved out of yellow cedar and then painted, the frog, craftily hiding the pad below, is surrounded by water made of cast bronze glass, which has frog's eggs incorporated into its design.

Camouflage
2000 | acrylic paint, yellow cedar, oxidized copper, bronze cast glass
40 inches in diameter × 5 inches

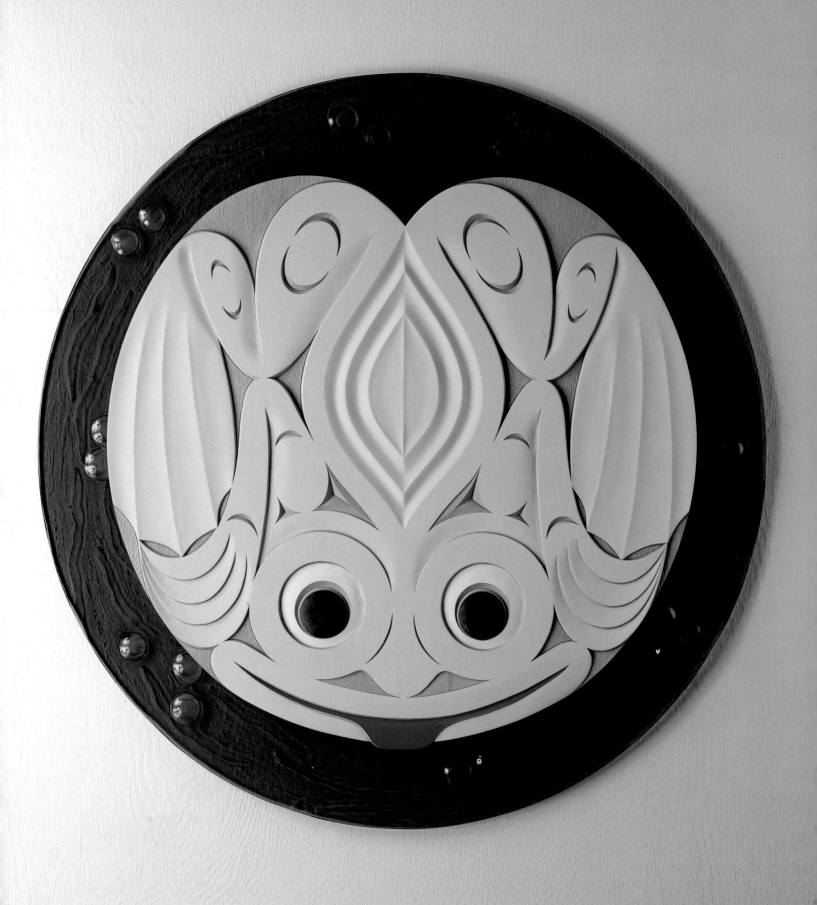

As viewers, unseasoned in the field of archaeology, we are often thrilled and inspired by ancient treasures. Gold and silver icons or mysterious and elaborate monuments of stone, fashioned by hands working hundreds or thousands of years ago, easily capture and even possess our imaginations. We wonder, Who created this? Why? What inspired this effort?

When an artifact is well defined and perfectly preserved for all eternity, it is easy to rationalize our attraction to it. But for archaeologists, and all those with insatiable imaginations, even the smallest fragments can alter a way of thinking or the direction of a creative spirit.

One such fragment was introduced to Susan Point in 1995. That year, the UBC Museum of Anthropology commissioned Point to re-create a group of small Coast Salish artifacts. Her only guides were prehistoric fragments made of antler, bone and wood. Some of these pieces were estimated to be three to four thousand years old. Armed with her strong research skills and a deep understanding of the nature of Coast Salish design, she set to work. The results were included in an exhibition, *Written in the Earth: Coast Salish Prehistoric Art*, which explored art from prehistoric archaeological sites located in traditional Coast Salish territories.

From the details of these small artifacts, Point created new pieces as pen and ink illustrations, colour renderings, and antler and bone carvings. Little did she anticipate, however, that one small fragment of charred wood, adorned with a barely discernible carved pattern, would revolutionize her creative direction.

Although all these shards of the past had a lasting effect on Point, the one that lingers in her mind is this charred piece of carved wood that may have come from the lid of an engraved wooden box over two thousand years old. The piece, only about 21 cm (about 8 inches) at its widest, was found at the Esilao dig site in the Fraser Canyon, where the burnt remains and debris from an ancient pit house were discovered.

Images

No discernible creatures or figures can be derived from the fragment, only lines travelling with an intent and purpose that will forever remain a secret. Out of these lines, however, Susan Point created *Images*, an exciting colour illustration depicting eagles, herons and creatures woven in a maze of design. The lines in this limited edition print appear continuous, forever moving through the characters in the piece. "Creating something from this fragment," Point recalls, "was much like a game I used to play with my kids when they were

younger. We would take turns drawing a series of lines and letting the other person extend the image to anything they wanted." In this case, a Coast Salish artist from two thousand years ago began the game, and contemporary Coast Salish artist Susan Point was challenged to finish it.

The unearthing of the fragment from the banks of the Fraser Canyon started a chain reaction. Elements of Susan Point's own ancestral vision were also unearthed with the fragment, as were memories, ideas and secrets. The fragment found a new and lasting voice in Susan Point. What started as one print has now become three, and a story that, on the surface, began in 1995 is much deeper, and originated a very long time ago.

Imagination

Like the second act of a three-act play, Susan Point's second piece inspired by the fragment is more subtle and internal to the artist. For *Imagination*, Point looked back in time. "I imagined the artist deep within the rain forest," she explains, "along the banks of the Fraser Canyon, where this particular piece was found, simply sitting and engraving the piece of wood on the forest floor." Point pursued this image with extensive research, discovering

unusual plants, like candy stick and ghost pipe (both from the Indian pipe family), which the artist may have seen while he or she carved. She also added bearberry, or kinnickinnick, a plant used as tobacco, and she included large slugs, creeping beneath the foliage.

Now, instead of seeing the fragment as part of a box, Point imagined it to be a woodblock, used for printing or stamping a mark wherever the artist wanted. Thus, in *Imagination*, the fragment, which is included in the body of one of the slugs, is reversed, as it would be for stamping. She also turned the fragment so that the grain was running vertically, as opposed to its horizontal direction in *Images*.

IMAGISM

Still not ready to be silenced, the fragment continued to inspire Point. For her third look at the fragment, she decided not to continue extending the lines. Point and the fragment instead looked to the future. "I considered what the fragment says to me," she explains, "about the past and what its presence has meant in the present, as well as how it will affect my work in the future."

The fragment has taken Susan Point into new and revolutionary artistic territory. *Imagism* is a passionate, striking contemporary design. Through the years, Point has mastered print-making techniques, and with this piece, she has pulled out all the stops, taking risks in combining methods for over- and under-printing to transform her vision of the piece into new and exciting realms. Point's use of fluorescent colours, pearl essence and a variety of textures is also a departure for her. The fragment, reinterpreted, is still present, but it has undergone a transformation as well.

The title for the third print, *Imagism*, is derived from a modernist movement in poetry that arose around 1912. Defined by American poet Ezra Pound, this style was characterized by concrete language and speech, clear, precise images, modern subjects and freedom in the use of metre. An exact visual image made an entire poetic statement. With *Imagism*, Susan Point adopted Imagism into the scope of the visual arts.

For this third piece, Point no longer looked at what the fragment or who the artist had been. The fact that the voice of that artist, which results from accumulated learning and skill, is still speaking and enabling the

transformation of thought and creativity in others, emerges as the central theme. The seeds of the past will grow in the future.

"When looking at this fragment, one not only sees a piece of this individual's illustration, but one also gets a glimpse of that person's skill and technique, used to make the image precise and deliberate," Point explains. "This talent developed, over the course of previous generations, making their life better. Myself, and many others, have spent a great deal of time studying this fragment. It's food for thought. The fragment has become a seed for me, which has given rise to suggest in *Imagism* how humanity takes from the past as we begin to shape the future of our evolution. I guess my third tribute to the fragment," she adds, "is meant to reflect the hope I wish for future generations and my belief in the human spirit to continue forever."

The central figure in *Imagism* is a magnificent creature, part human and part bird, in the midst of a great transformation. The unique printing process for this piece allows the eye of the viewer to be tricked, seeing either creature at one time or another. This

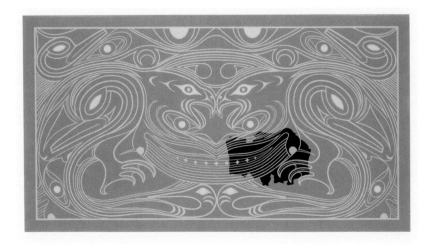

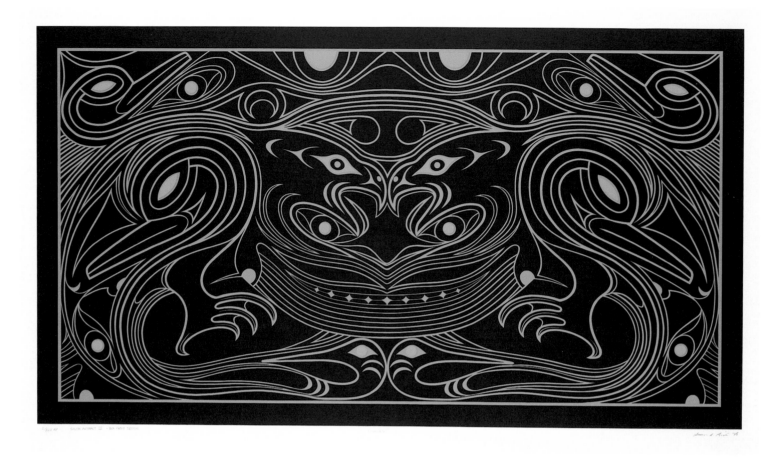

transformation illustrates humanity's quest to reach the stars. The figure is framed by a cliff-like shape, referring to the Fraser Canyon, where the fragment was discovered. The spheres, celestial bodies, along the left side of *Imagism*, symbolize the leaps of humanity, inspired by our fascination at delving into our past. "The overall image," Point explains, "suggests endless possibilities for our future." The fragment, appearing in the bottom sphere, has been altered to fit in the circular shape. This suggests its continuing ability to shape our imagination, even after all this time. The bold use of colour is how Point emphasizes

that we can use all means and media available to bring forth our thoughts and, by experimenting with the unknown, expand our skills.

With *Images*, *Imagination* and *Imagism*, Susan Point has made a transformation of her own. The fragment, by its nature, defies explanation. It can't be contained by the boundaries of what it may have looked like or what its purpose may have been. Instead, it inspires introspection. It has a purpose now, which may be different than it was then. Point's perspective has expanded. The limitless future has become her canvas and her eagerness to embrace her journey is an inspiration to others.

FRAGMENT

That which survives lies resting,
nearly forgotten, nearly silenced.
It remains unburdened
by time or illusion.

The future lies buried
beneath the surface of the past,
waiting to be unearthed.

Intangible, defying easy definition,
the fragment, like a bird with wings poised,
seeks new direction,
transformation forward
through delicate, younger hands.

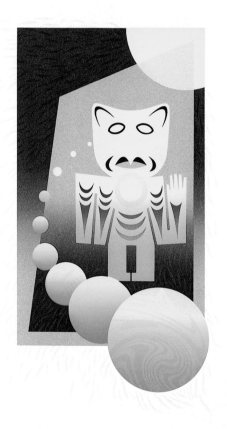

Images, Imagination, Imagism
(set of two serigraphs, one woodblock)
2000 | respectively 23 × 37 inches, 21 × 15 inches, 24 × 18 inches
edition of 25 each

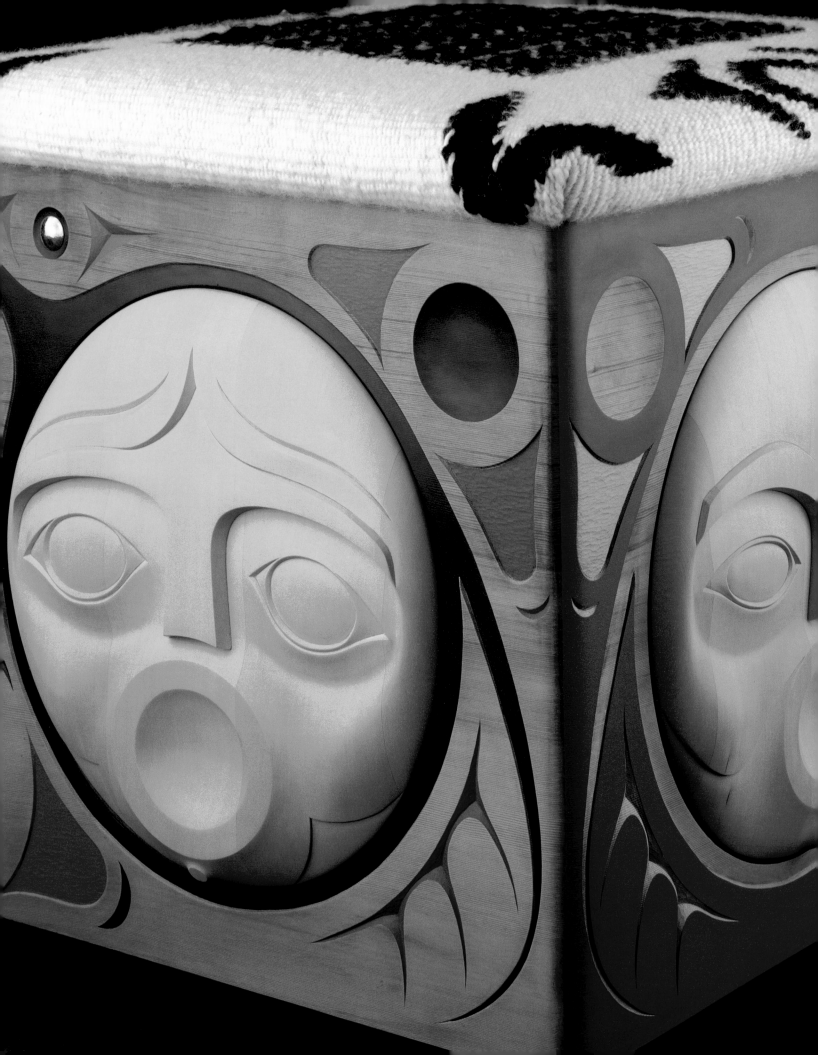

I love to create new and contemporary imagery

in my *interpretation* *of Coast Salish style,*

but every so often I need to pay *tribute* *to classical design—*

to grab on to the *roots* *of my beginnings.*

—SUSAN POINT

Celebration of Differences

Says Susan Point, "This piece is about the age-old story of fear and doubt, ignorance and misunderstanding, which leads to anger." Point often integrates the theme of "peoples from the four directions coming together and forming a multicultural society" into her work. As she says, "All too often we look away from or mistrust others because they are different in appearance, customs or beliefs." In *Celebration of Differences*, each of the four characters in the piece has a strong presence and a unique point of view—one not shared or acknowledged by the others. Their differences are striking. Perhaps even more remarkable, though, are their similarities, of which they may not even be conscious.

Whenever we see a box of any kind, it is hard to not wonder what is inside. Symbolically, the contents of this box

are shared by the four characters. It is what they share—values, heart and humanity—that makes them, and us, stronger. The goose images, in positive and negative, link the faces and symbolize movement and migration. Through this bird, which is known for its habit of migrating to other lands and cultures, it becomes possible for us to see or to move toward the other points of view in this piece.

Traditionally, bentwood boxes were used to store blankets, ceremonial regalia, food and cooking utensils—the essentials of life. The blankets supply warmth and security, the regalia is a vehicle for cultural and spiritual practices, and the food, bowls and cooking utensils offer nourishment. All these items are essential for the health of a community, regardless of race, culture or religion. Point has added a further element, that of support, to the story of the piece, by placing a Salish weaving on the top of the box, giving it

the appearance of a bench. "Support," according to Point, "is what we accomplish when we all work or come together."

The theme of bringing people together to contribute to the greater good extends to the construction of the piece. Susan Point gathered many of her friends to share in the process. Tom Hunt assisted in the carving of the yellow cedar faces while the red cedar box was skillfully bent by Larry Rosso, from material supplied by John Livingston. The lid was made by Peter Grant, and the exceptional Salish weaving for the top was provided by Point's niece, Krista Point. Each of these contributions complements Susan Point's original design and unique carving style.

Celebration of Differences
2000 | red cedar, yellow cedar, bronze, Salish weaving (wool)
34 × 30 × 30 inches

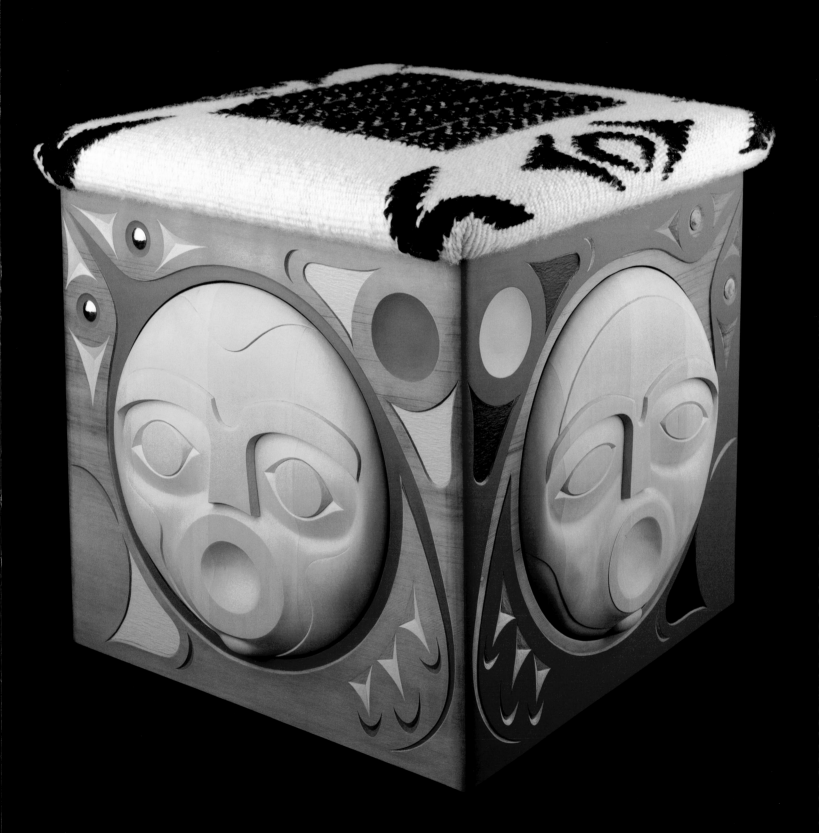

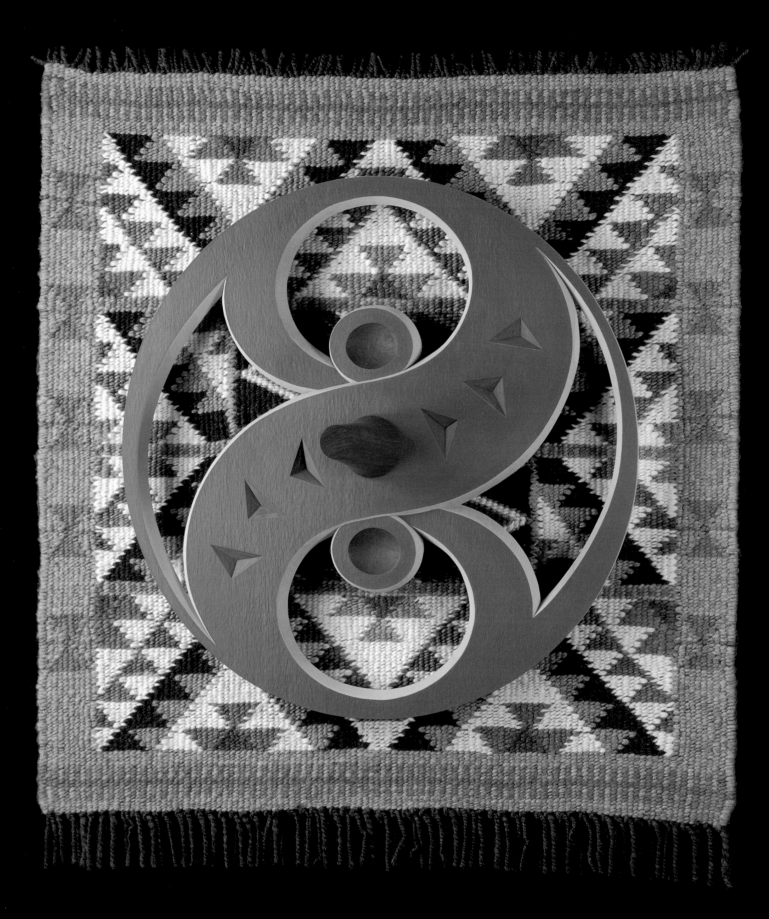

Collaboration is a unique work that demonstrates its title on different levels. Separately, the whorl and the woven blanket are outstanding works of art. Together, they become something exceptional. They tell a story about two opposites coming together in a working, balanced relationship.

Perhaps the most obvious collaboration is that the piece depicts a large wooden spindle whorl piercing an intricate Salish weaving. The traditional function of a spindle whorl is to spin wool into yarn for weaving. This piece is an example of the relationship between the tool and the final product it is used to create. On a more human level, it is also the result of a collaboration between Susan Point and her niece, Krista Point, a prominent Coast Salish weaver. The incisions within the whorl shape, which allow for more interaction with the woven design, depict two human head silhouettes, illustrating Susan

and Krista working together toward a common goal. Two works become one, as do these two unique artists.

Collaboration also achieves a strong balance between the hardness of the wood and the soft, supple nature of the weaving, between the round shape of the whorl and the square of the textile, and between the personalities of the two artists.

Krista Point has been weaving for nearly twenty years. Inspired by traditional designs found on baskets and woven pieces in the collection of the University of British Columbia Museum of Anthropology, she has become skilled at combining a strong sense of Coast Salish style with her personal aesthetic. She is particularly fond of the dominant zigzag pattern used in this and other pieces. "It has a few different meanings—a trail or a snake as well as lightning," she says. "It has a lot of strength and power." As seen in the border of the weaving, Krista uses the Salish butterfly pattern in most of her weavings.

To find the perfect colours for the patterns, Krista hand-dyes her yarns, using natural dyes derived from onion skins, dandelions, goldenrod flowers, stinging nettles, horsetail, red onion skins, red alder bark and even lichens. "The colours," she describes, "are energy forces that affect us positively or negatively, altering our moods and awareness."

"As the years go by, I'm more and more inspired by the many different designs I have used on the blankets, shawls, bags and pillows," Krista explains. "Every project I do is special to me and I strive to do better with each one."

Collaboration
2000 | red cedar, padouk, Salish weaving (wool), acrylic paint
54 × 48 × 8 inches

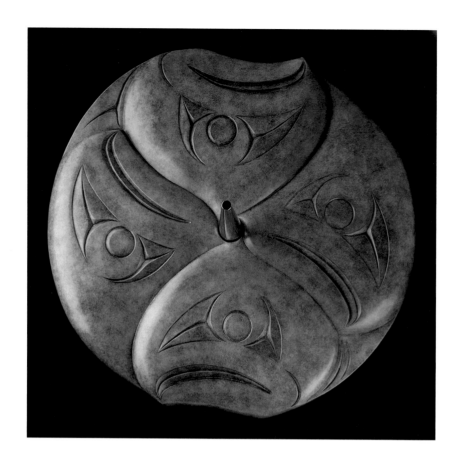

Salmon Gathering

Like many of Susan Point's creations, *Salmon Gathering* reflects the symbolic nature of four. The asymmetrical design features four salmon heads set in deep relief, referring to their four-year cycle of life, the four seasons that govern those years and the activities involved in Coast Salish traditions. The salmon portrayed in this sculpture are heavy and solid, a sure indication of their prominence in Salish culture.

"The salmon," Point explains, "are considered fortuitous to many First Nations and, in some cases, a key component of our way of life, whether gathering to celebrate and feast or to barter for essentials."

Cast in bronze, this smooth and powerful whorl spreads 1.4 metres (4.5 feet) in diameter. It has been produced in a limited edition of three, each featuring a different patina and a different method of presentation.

Salmon Gathering
2000 | bronze | edition of 3 | 4.5 feet in diameter × 18 inches

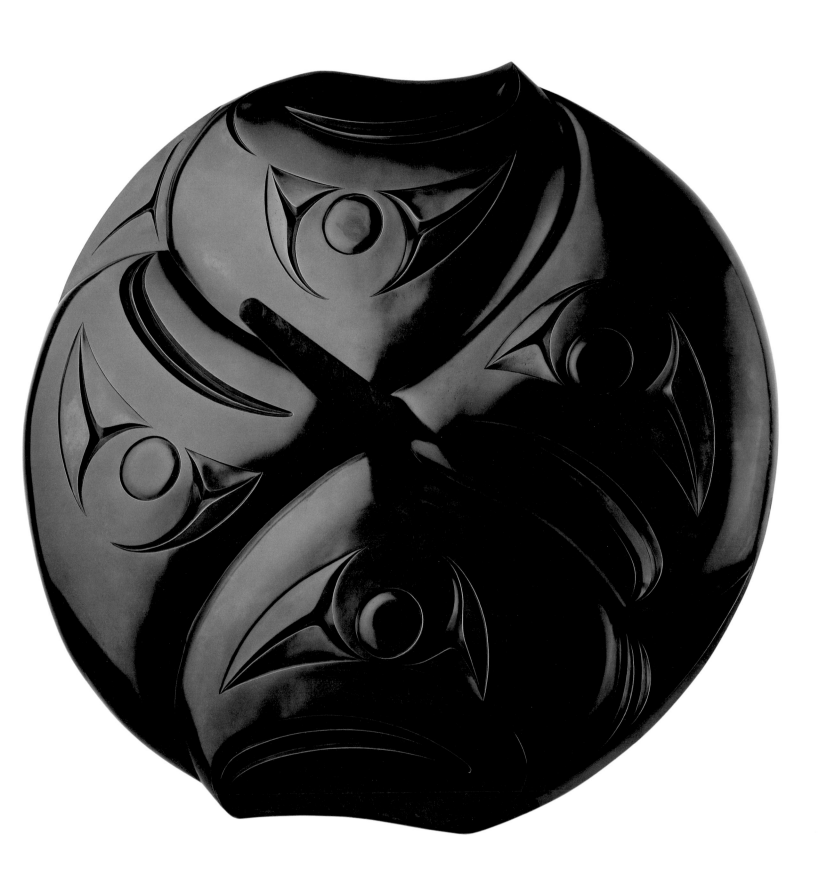

The Mahli

Susan Point fondly recalls childhood memories of her parents cutting wood in the mud flats near her home, an area of the Musqueam reserve called the mahli (pronounced "mollie"). She and her brothers and sisters would play among the bulrushes (or cattails). A great number of birds were also there playing with the children, and Point especially remembers the hummingbirds.

This piece, titled *The Mahli*, is a sentimental one for Point. "My mother used to make mats from the blades of these bulrushes," she explains. "She tried teaching me the process: collecting the bulrushes, taking the blades apart, drying them in the sun, which took some time (depending on the weather), and then weaving the mats. She also tried teaching me to make rope from dried bulrush blades," she adds. "I never did master either, but I wish I did. Now that she's gone, I guess I never will learn."

When we hear someone talk of weaving mats, small floor coverings usually come to mind. The mats Point is talking about were gigantic by comparison. These woven pieces were used to line the inside walls of family houses, making them easy to transport as families moved from place to place gathering resources like fish, berries and other necessities. To make such immense pieces that could withstand wind and travel would require great ingenuity and skill.

Susan Point's interpretation of *The Mahli* is a hand-blown coloured glass screen with a maple frame in the shape of a house, symbolizing the Musqueam village. The vast expanse of the piece readily brings to mind the reedy, open sense Point must still experience as she and her husband walk through the area with their own children, using washed-up logs as pathways, delighting in the breezes and the rich sunsets.

"The imagery in this piece," says Point, "reflects the bulrushes in the mahli area, with the sun to the left and the moon to the right. In the centre of the glass screen is a classical Coast Salish weaving pattern. I included a hummingbird in this piece as well because my mother loved hummingbirds so much. I was thinking about her when I was creating this piece." Wave images run along the bottom of all three panels of the screen, seemingly from one to the next, as it does along the south shore of the Musqueam reserve where Susan Point has spent her whole life.

It is interesting to notice how a screen is constructed. When the two sides are closed in, we can only imagine what the inside must be like. This work of art offers a rare glimpse into the memories from Point's childhood that have left a lasting impression on the adult and artist she is today.

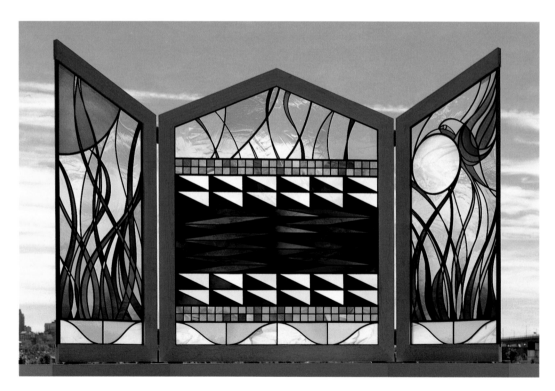

The Mahli

(three-section screen) | 2000 | handblown glass, maple
6 feet × 11 feet × 3 inches

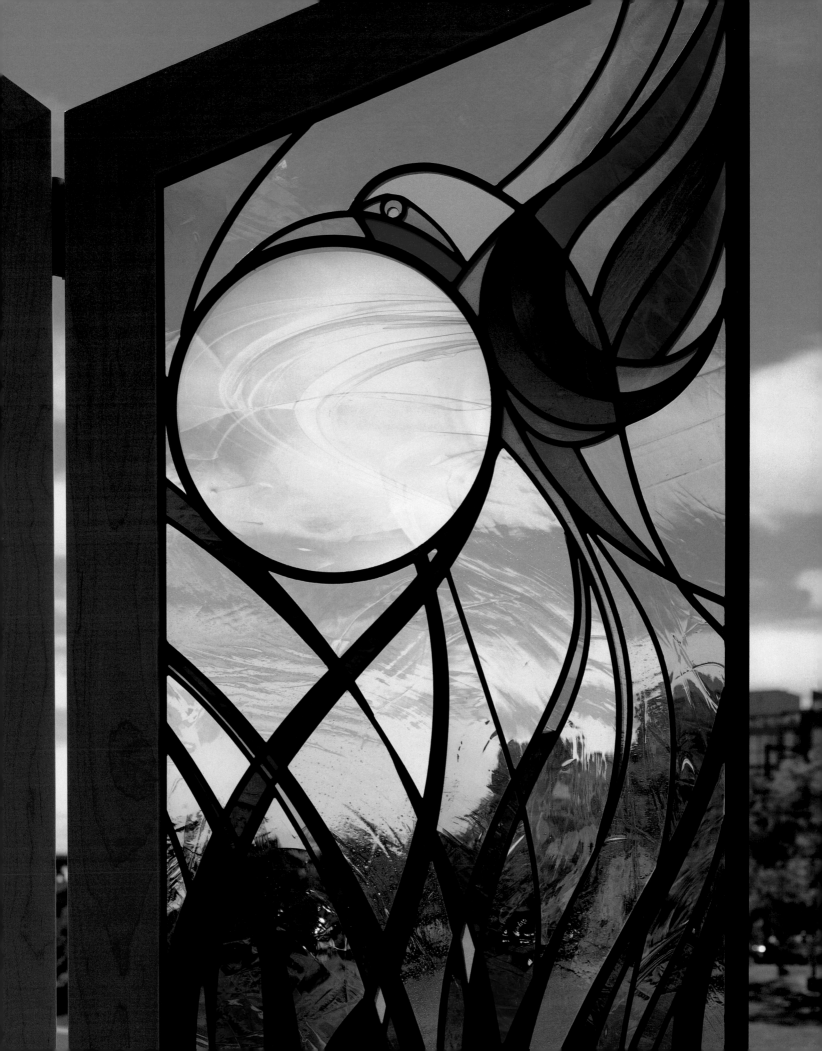

Pacific Spirit 2000

The Pacific Spirit Run, a 10-kilometre (6.2-mile) run through the University of British Columbia Endowment Lands, is a fundraising event for local hospital charities. The year 2000 is the eleventh consecutive year Susan Point has supported this event by designing the logo and allowing the image to be used for fundraising purposes. Point has often produced a limited edition print, and on a few occasions, a painting that has been auctioned and a limited edition poster of the image.

"This image, as all images that I have made for the Pacific Spirit Run," says Point, "relates directly to the area where the run takes place. It represents tree frogs, which are abundant in the UBC Endowment Lands. Frogs in general are significant for the Coast Salish people. They relate to the season of spiritual dancing in our longhouses during the winter months."

Point adds, "The design also portrays coming together. Although at first glance the work may appear to be a repeat design, there are subtle differences within each frog, just as there are cultural and other differences among all those who participate in the annual run."

Pacific Spirit 2000
2000 | serigraph | edition of 200 | 38 × 36.5 inches

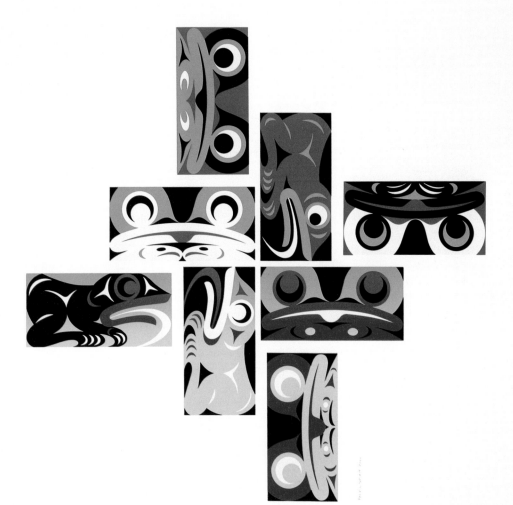

Salish Comb

Elaborately carved combs were used by the Coast Salish people and throughout the Northwest Coast. The unique carving style of different villages and nations was evident in the combs produced. Combs were prestigious commissions bearing the crests of the owner. As small, portable objects, they were ideal gifts for someone of prominent status who had travelled a great distance to be a ceremonial witness. The powerful carving represented the skills of the artists from the host village and the crests of the host family. Combs were also personal amulets historically associated with spiritual leaders.

Salish Comb
2000 | 14-carat gold, argillite | 6 × 2 × 5/16 inches

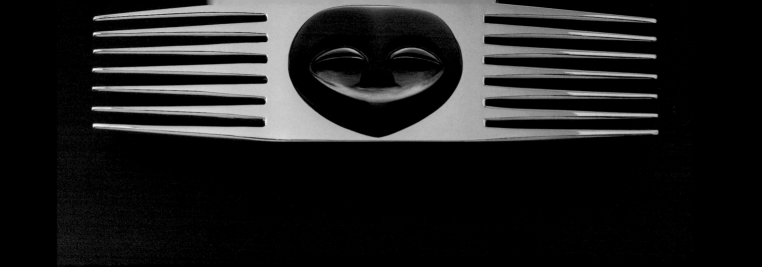

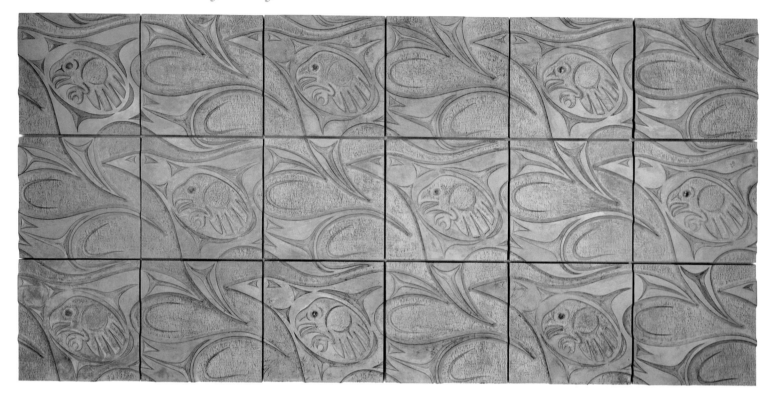

From water flows all life.

The Essence of Life Continued
above | detail on facing page
1998 | patinated bronze polymer
6 feet × 12 feet × 4 inches

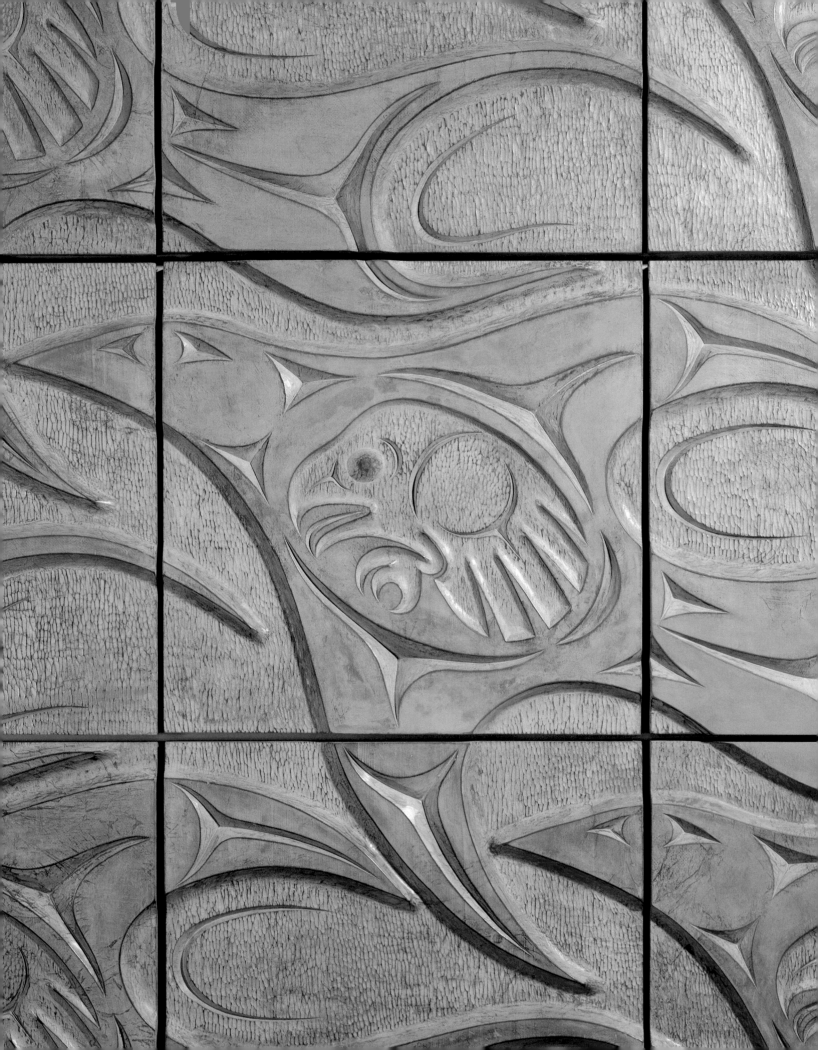

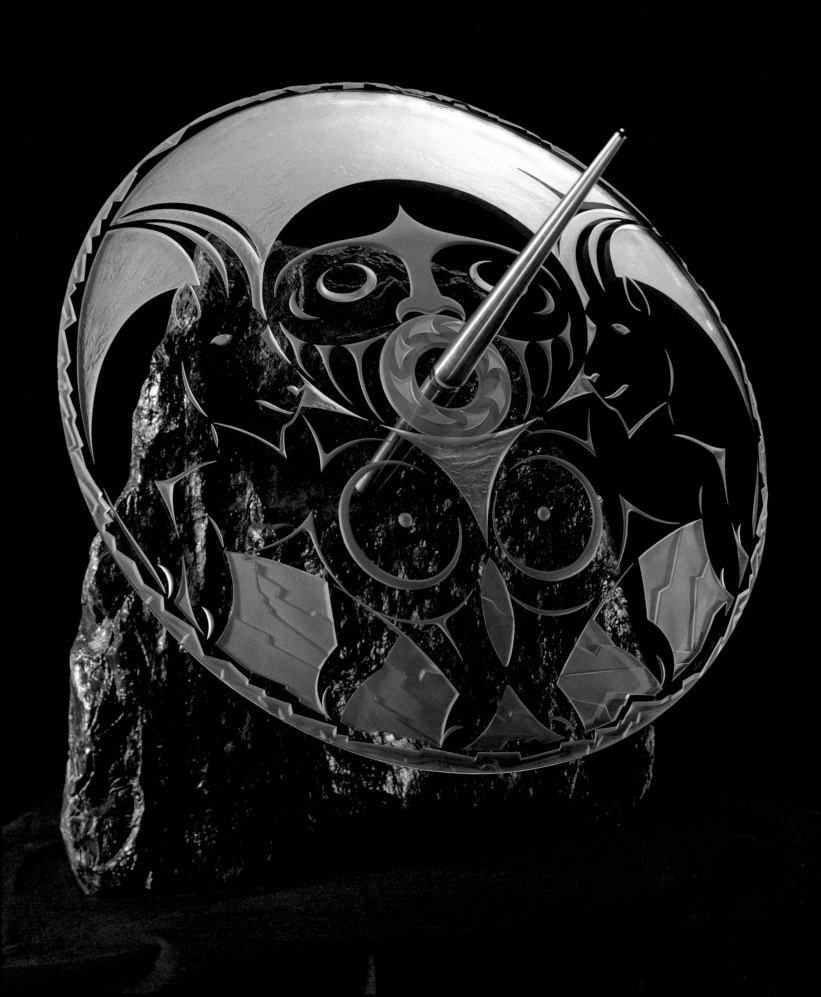

As the title suggests, this spindle whorl piece explores the delicate nature of pushing boundaries, as depicted by two mountain goats poised on the edge of a craggy cliff. It illustrates a moment of decision and commitment. The precarious nature of this decision depicted in *On the Edge* is symbolized by the fragility of the glass whorl anchored, with only a light stainless-steel spindle, through to the rough and unforgiving base fashioned from Texada marble. The face of the woman in the centre of the design, the weaver tying all of these elements together, is in keeping with Salish tradition, as whorls from the time of European contact often, but not always, contained a human component.

Each of the elements in this piece symbolically relates, through function, to other elements. The spindle whorl was traditionally used to spin wool from mountain goats into yarn. The mountain goats need to challenge the stability and treachery of the mountain to find food. The spindle whorl must be able to spin freely and delicately, precisely balanced and without security to be effective. For each, the success of the relationship is never easy or guaranteed.

For those of us exploring *On the Edge* in the relative comfort and safety of a gallery or book, testing extreme limits and pushing boundaries is merely a theoretical concept. For the mountain goat, however, it's part of life.

On the Edge
2000 | carved glass, stainless steel, Texada marble | 40 × 40 × 30 inches

Circle in Time

"Although I initially started studying and drawing old whorls with bird, human and animal forms," Susan Point explains, "I have always admired the old whorls with simple geometric and floral imagery."

With no end and no beginning, this carved glass spindle whorl illustrates the unwavering passing of time. Point also earlier depicted the same design in a limited edition serigraph of the same title. Each geometric moment on the whorl is identical to the one before it and the one that follows. Whether the marks indicate seconds, days, years or millennia, the pace never changes regardless of the culture it is being measured in.

"It amazes me," Point admits, "how many of these motifs and symbols decorate early ornaments and objects globally."

Circle in Time

1998 | carved glass, acrylic paint, red oak, yellow cedar
edition of 4 | 18 inches in diameter

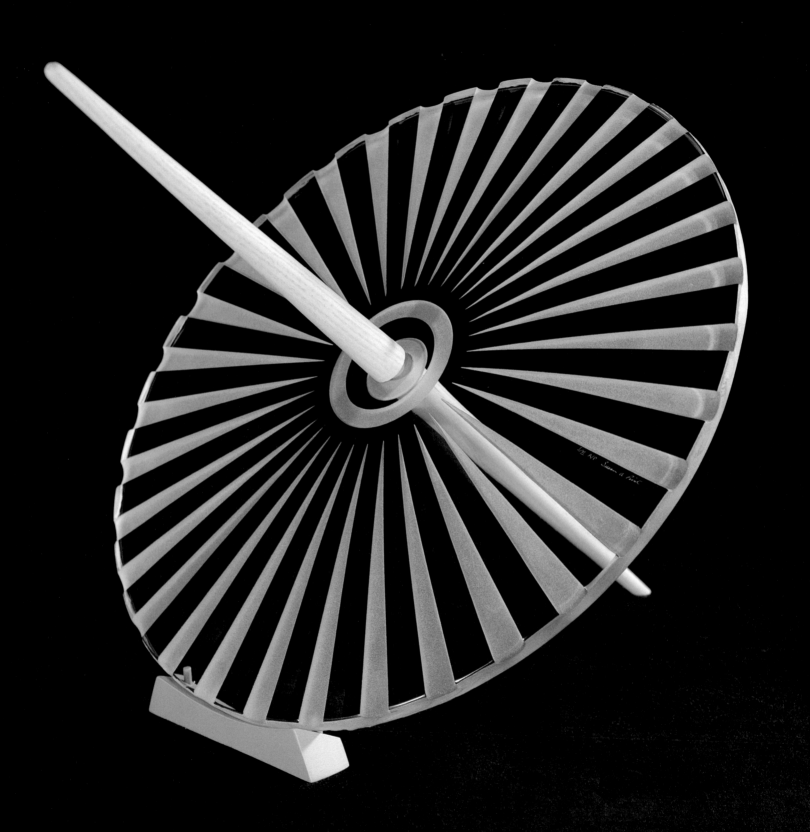

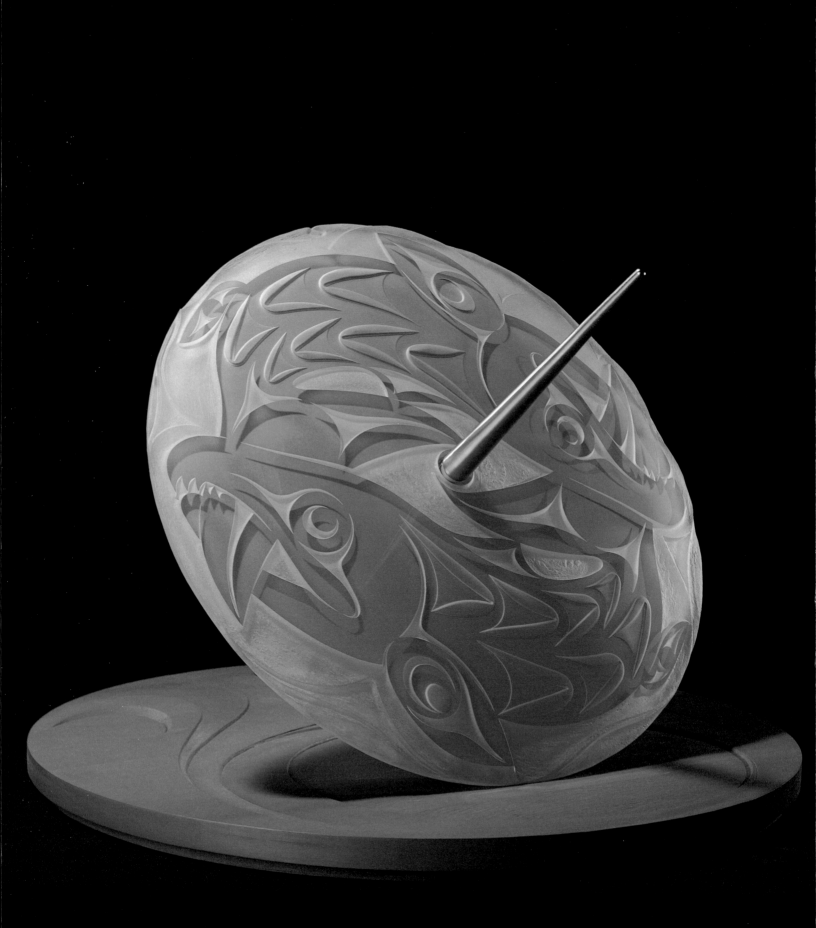

Sockeye Battle

Protecting her spawning ground.

Sockeye Battle
2000 | carved glass, stainless steel
yellow cedar base 36 inches in diameter × 30 inches

Survivor

This piece, featuring a design Susan Point has returned to in various mediums throughout her career, is graced with very personal significance that remains private to the artist. "As my ancestors created works of art which had personal and spiritual meanings to them," Point quietly explains, "I, too, have created a work of art that has a personal meaning to me."

For Point, the meaning touches on the loss of loved ones. Deeply intimate, this glass sculpture featuring four salmon requires only an introspective appreciation for one artist's journey.

Survivor
1999 | carved glass, 24-carat gold leaf | edition of 4
24 × 24 inches | plus glass base

Continuing Journey

Even with all our advances in technology and the extent to which we can dominate the natural world, have we as a society really evolved? "With all our new technology and modern-age gadgetry," muses Susan Point, "it occurs to me that we, as the human race, are still very primitive."

Point's thoughtful look at where we are as a species, *Continuing Journey*, relates to the human race's progress through time, assessing our place in the future and this new millennium.

Free to soar above our limited perception of our place in the order and scale of the universe, the eagle in this carved piece carries humanity forward. The human face in the centre of the eagle, is designed in a primitive Coast Salish style, and Point has painted it to highlight the under-developed nature of our awareness. In particular, the eyes of this person seem limited in their vision and unaware of their surroundings.

"Sometimes," Point explains, "I feel that we're too involved in the race and too confident about our future.

When you think of our existence in universal time, we are so young and naive. Maybe we need to use some of the extra time advanced technology has granted us to reflect on the past and the present, challenging our minds and our ability to reason to see where and how we want to evolve on the long journey ahead."

Continuing Journey
2000 | acrylic paint, red cedar, cast glass
7 feet × 4 feet × 7 inches

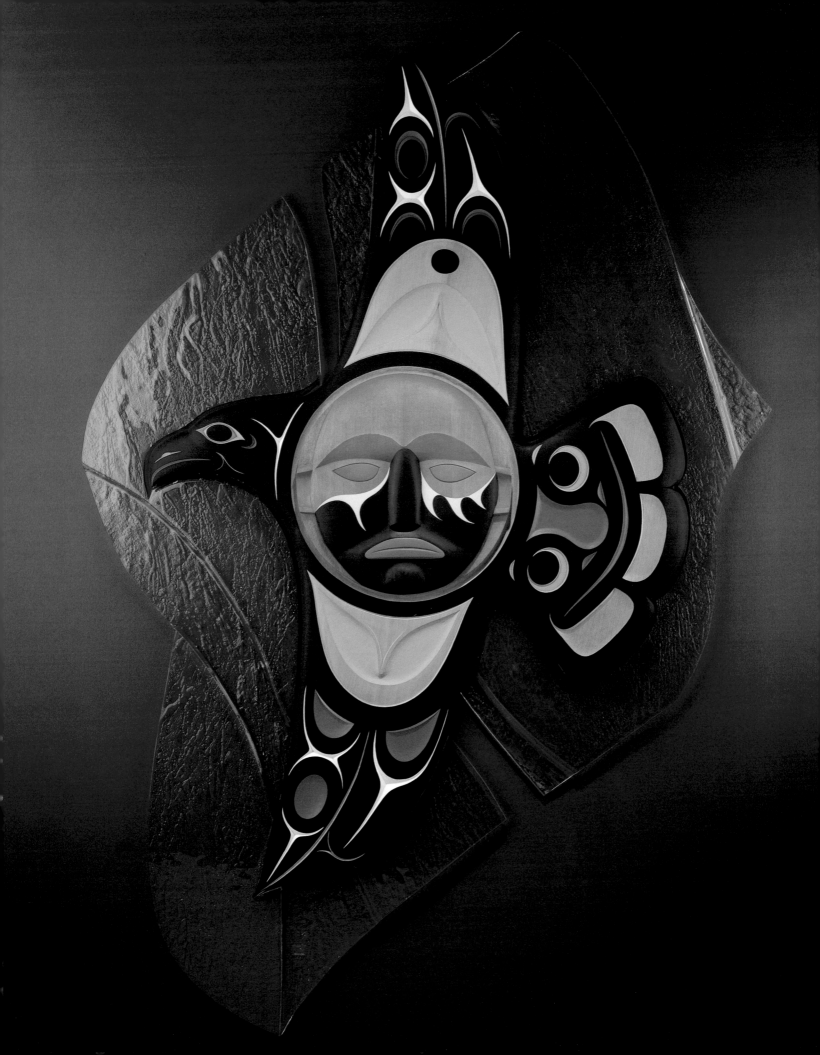

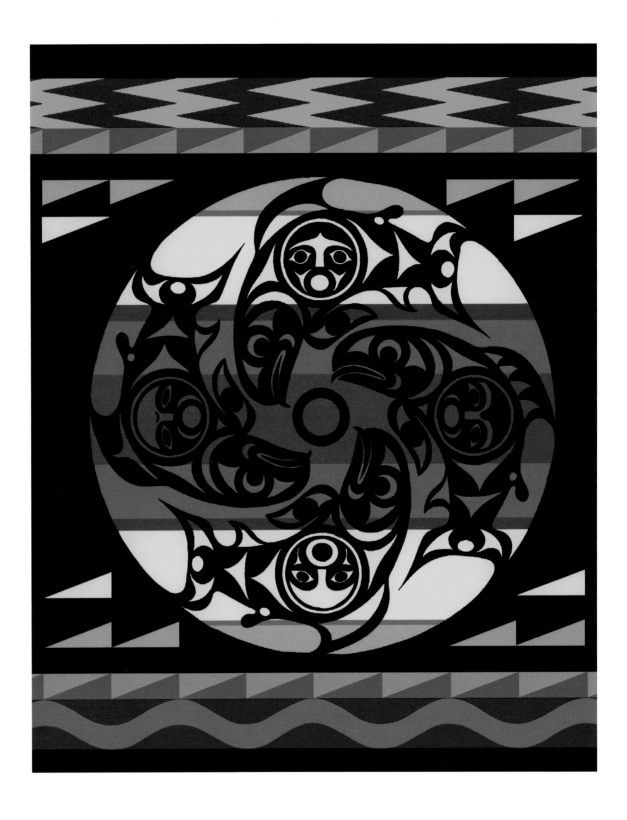

According to a Salish legend known as the Salmon People, it was customary in the early days for the Coast Salish people to bathe their babies in stone bowls. These bowls were believed to have special powers that helped the children grow strong and wise. A Coast Salish woman, having just given birth and being of good faith, asked her younger brother-in-law to search for a smooth, hollowed-out rock in which she could bathe her child. He looked, but he couldn't find anything. Taking matters into her own hands, she decided to look for herself.

As the woman walked along the beach, she discovered the perfect hollow rock. But each time she tried to pick it up, the rock would roll away from her toward the water. When she followed the rock into the water, it transformed into a sockeye salmon and kidnapped her, taking her to the bottom of the sea. After one year, she was returned to her people. The woman told them of her disappearance, and how her captors, the

Salmon People, lived in a village deep in the bottom of the ocean. She also told of their great numbers, which represented the abundance of sockeye salmon in the area.

This story inspired Susan Point's blanket, *Salmon People*, which is her interpretation of the traditional Pendleton blankets from Oregon that featured strong and powerful native-based designs. "I have always admired the Pendleton blanket," Point admits, "especially some of the southern native styles. I was very excited to do a Salish-style Pendleton blanket, which is not so much a Salish blanket," she continues, "but more of a Susan Point blanket. It is a version of my first design with borders complementing the textile art of my ancestors, inspired by classical Salish weavings."

Susan Point uses her well-established spindle whorl motif as a foundation for this piece. The two sides feature a traditional, geometric-patterned border. Inside the centre whorl shape, Point illustrates the world of the salmon people—their swirling bodies merging salmon and human characteristics.

"The only problem I had," Point recalls, "was deciding what to do because I had too many ideas in my head. Coming up with the colours for this blanket," she adds, "was also a challenge because the process limited me to only two colours per woven line."

In Coast Salish tradition, blankets were a valued form of currency and a symbol of wealth. The unique style of Salish weaving produced blankets that were traded, given as gifts at potlatches and worn for ritual where elaborately carved pins or clasps held them together as they were worn. Creating this blanket has inspired Point to look more closely at pursuing other blankets as a further expansion of her range of artistic mediums. "I would definitely like to try to do others if I ever get the opportunity. Someday I would like to do both a very contemporary blanket and a very traditional one."

Salmon People
2000 | wool | 64 × 80 inches

Coming Back

In the wall sculpture *Coming Back*, Susan Point illustrates the powerful and recurring theme of salmon triumphantly completing their life cycle. This piece, however, has a dual purpose, highlighting a revitalized appreciation for the Coast Salish art form. "Not only does it represent the journey of the salmon as they come back each year to spawn," Point explains, "but it also represents the fact that Salish art is coming back."

The salmon are a metaphor for the theme of change along a journey. Each carries a spindle whorl, adorned with Salish crescent forms that progressively change and expand from one whorl to the next, and each contributes to the overall design. The spinning of the spindle whorl represents the circle of life continuously in motion. Point has chosen to use round whorls, rather than soft-squared or other shapes, to further emphasize the easy, unaffected rotation of the circle.

As a tribute to the diversity available in the sculptural medium, Point carved the first salmon (on the bottom) out of red cedar. She then made a rubber mould of the piece and cast three more identical salmon in coloured paper. Bright colours for these three were chosen to symbolize different stages of the salmon's journey as well as illustrate the unrestricted possibilities of Coast Salish art in different and contemporary mediums. "Not only do salmon change colour in the time before spawning," Point notes, "but art, in general, also changes over time."

Coming Back
2000 | red cedar, oak, hemlock, walnut, handmade paper
7 feet × 14 feet × 7 inches

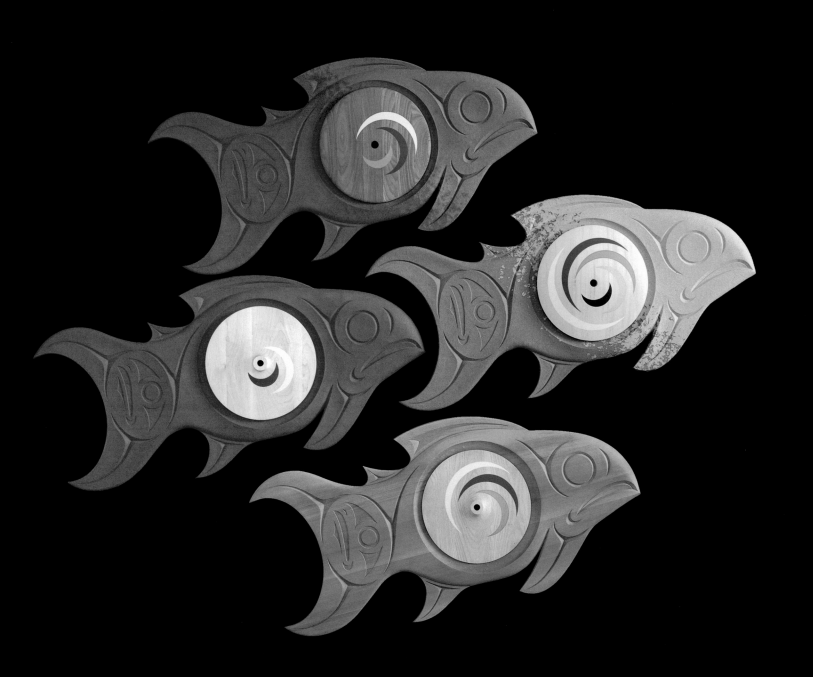

Chronology

1981 Commission

Grizzly Bear with Sockeye (design for coat of arms), Municipality of North Vancouver, B.C.

1982 Exhibition

Art of the Northwest Coast (selected artists), London Regional Art Gallery, Ont.

1983 Exhibition

Native Indian Exhibition (solo exhibition), Delta Museum and Archives, Ladner, B.C.

Commission

Kwantlen (limited edition print of 100), Kwantlen College, Surrey, B.C.

1985 Exhibitions

Coast Salish Art (group exhibition), East Lake Gallery, Bellevue, Wash.

Images of Coast Salish Culture (selected artists), Fraser Valley College, Abbotsford, B.C.

Northwest Coast Native Art Show (group exhibition), Sacred Circle Gallery of American Indian Art, Seattle, Wash.

The Northwest Coast Native Print (selected artists; catalogued exhibition), Art Gallery of Victoria, Victoria, B.C.

Commissions

Raven (poster design), Fraser Valley College, Abbotsford, B.C.

Salmon People (poster design to commemorate the exhibition *Northwest Coast Indian Prints*), Richmond Art Gallery, B.C.

Appointment

Elected council board member of the Musqueam Indian Band; served until December 1994

1986 Exhibitions

All Native Indian Women's Show (selected artists), Images for a Canadian Heritage Gallery, Vancouver, B.C.

Cultural Treasures (selected artists), University of British Columbia Museum of Anthropology, Vancouver, B.C.

New Visions: Serigraphs by Susan A. Point, Coast Salish Artist (travelling exhibition), University of British Columbia Museum of Anthropology, Vancouver, B.C.

Northwest Coast Indian Art (selected artists), Robson Square Media Centre, Vancouver, B.C.

Pacific Northwest Art Expo (selected artists), Seattle Trade Center, Seattle, Wash.

Salish Images: Northwest Coast Artists Tribute to Salish Art (selected artists), University of British Columbia Museum of Anthropology, Vancouver, B.C.

COMMISSION

Red Oak (design for cast iron tree grate sculpture for various locations in Seattle), Municipality of Metropolitan Seattle, Wash.

1987 EXHIBITIONS

Coast Salish Impressions (solo exhibition), Gateway Theatre, Richmond Art Gallery, B.C.

Susan Point (solo exhibition) Eskimo Art Gallery, Montreal, Que.

COMMISSION

New Beginnings (logo design), Northwest Tissue Center, Seattle, Wash.

1988 EXHIBITIONS

Gallerie—Women's Art; Women in Focus (selected artists; exhibition and book), Vancouver, B.C.

In the Shadow of the Sun (selected artists; travelling catalogued exhibition in Canada, England, France, Japan and the United States), Canadian Museum of Civilization, Hull, Que.

New Visions: Serigraphs by Susan Point, Coast Salish Artist (travelling solo exhibition), Steilacoom Tribal Museum, Steilacoom, Wash.

La Nouvelle Collection (selected artists), Le Service de Prêt et Vente des oeuvres d'art, Centre Culturel de Point Claire, Montreal, Que.

COMMISSIONS

Beaver and the Mink (calendar design), Public Service Commission of Canada, Toronto, Ont.

Equality (poster design and limited edition print of 70 for a human rights conference), Affiliation of Multicultural Societies and Services Agencies of British Columbia, Vancouver, B.C.

Killerwhale and Calf (limited edition gold foil–embossed serigraph of 1,000 for Visa America), Western Pacific Engravers, Vancouver, B.C.

Slahal (acrylic on canvas painting), British Columbia Lottery Corporation, Kamloops, B.C.

1989 EXHIBITIONS

Art Salish (selected artists), Guilde Canadienne des Métiers d'art Quebec—Canadian Guild of Crafts Quebec

Beyond Revival: Contemporary Northwest Native Art (selected artists; catalogued exhibition), Charles H. Scott Gallery, Emily Carr College of Art and Design, Vancouver, B.C.

Fear of Others (art exhibit against racism; selected artists; travelling exhibition in Canada), Vancouver, B.C.

From Periphery to Centre: The Art of Susan and Krista Point (catalogued exhibition), Thunder Bay National Exhibition Centre and Centre for Indian Art, Ont.

Susan A. Point (solo exhibition), Sandia Galerie fur Indianerkunst Nordamerikas, Basel, Switzerland

Susan A. Point, Joe David, Lawrence Paul: Native Artists from the Northwest Coast (catalogued exhibition), Ethnological Museum of the University of Zurich, Switzerland

COMMISSIONS

Pacific Spirit (logo design, first of eleven consecutive annual commissions), University of British Columbia Hospital Foundation for the Pacific Spirit Park Run, Vancouver, B.C.

Salmon (logo design), British Columbia Aboriginal Peoples' Fisheries Commission, Vancouver, B.C.

Welcome Figure (woodblock and limited edition print of 35 for Endeavour '89), Endeavour Society, Vancouver, B.C.

1990 EXHIBITIONS

Changing Forms, Enduring Spirit (selected artists), Anne Gould Hauberg Gallery, Pacific Arts Center at the Seattle Center, Wash.

Contemporary Coast Salish (selected artists), Thomas Burke Memorial, Washington State Museum, University of Washington, Seattle

In the Shadow of the Sun (selected artists; travelling exhibition), Art Gallery of Nova Scotia, Halifax

In the Shadow of the Sun (selected artists; travelling exhibition), Rejksmuseum, Leiden, Holland

Salish Design: Drums, Paintings and Prints by Susan A. Point, Coast Salish, The Legacy Ltd., Seattle, Wash.

Salish Point (solo exhibition), Canadian Museum of Civilization, Hull, Que.

Susan A. Point (solo exhibition), The Art Space Gallery, Philadelphia, Penn.

COMMISSIONS

Spawning Salmon and Two-Headed Eagle (designs for use on concrete buildings), Dominion Company for the Sechelt Band, Vancouver, B.C.

Textile design (for jackets for the Khahtsahlano road race), Alpine Meadows, West Vancouver, B.C.

1991 COMMISSIONS

Enlightenment (logo design and limited edition print of 100 for annual convention in Sardis, B.C.), Federated Women's Institutes of Canada

Raven with Spindle Whorl (house post), University of British Columbia Museum of Anthropology, Vancouver, B.C.

The Seal and the Raven (carved and painted red cedar panel for theatre), Sechelt Indian Band, Sechelt, B.C.

Two Headed Eagle (acrylic on canvas painting for theatre), Sechelt Indian Band, Sechelt, B.C.

1992 EXHIBITIONS

Exhibition (two women artists), The Art Space Gallery, Philadelphia, Penn.

First Northwest Native Women's Art Exhibition (selected women artists), Granville Native Art Gallery, Vancouver, B.C.

Here Today (two artists), Open Space Gallery, Victoria, B.C.

Exhibition (selected artists), Museu da Gravura Cidade de Curitiba, Curitiba, Parana, Brazil

COMMISSIONS

Black Bear Children (carved and painted red cedar spindle whorl for B.C. Tourism and the Tenth Annual North American Tourism Convention in Seattle), Potlatch Arts Ltd., Vancouver, B.C.

Eagle and Wolf, and Man and Salmon (textile designs embroidered on the lapels of the Speaker's jacket), Speaker of the House, Parliament Buildings, Victoria, B.C.

Land, Sea and Sky (36 banners of Coast Salish motifs for the Vancouver International Airport Main Terminal), Vancouver International Airport Authority, Richmond, B.C.

The Northwind Fishing Weir (six-piece sculpture of Coast Salish spirit planks in concrete and red cedar), King County Arts Commission, Seattle, Wash.

Painted drum (presented to musician Bruce Cockburn), Voices of the Earth Foundation, North Vancouver, B.C.

Painted drum (presented to Prince Philip, Duke of Edinburgh), Voices of the Earth Foundation, North Vancouver, B.C.

Poster design (edition of 100,000 to commemorate the International Year of the World's Indigenous People), Department of Indian and Northern Affairs, Ottawa, Ont.

Sea to Sky (stainless steel and coloured glass mural for the Natural Resources Building, Olympia), Washington State Arts Commission

Voices of the Earth (logo design), Voices of the Earth Foundation, North Vancouver, B.C.

Wolf People (carved and painted red cedar kneeling stool to accompany chancellor's chair, speaker's podium, talking stick and ceremonial mace stand; a nine-artist commission representing all major tribal groups of the Northwest Coast, donated to the University of Victoria), Michael Williams

APPOINTMENT

By the British Columbia provincial government to the board of directors for the Emily Carr College of Art and Design (now, Emily Carr Institute of Art and Design) for the first of three consecutive terms; served until 1998

1993 EXHIBITION

Exhibition (selected artists), The Western Gallery, Western Washington University, Bellingham, Wash.

COMMISSIONS

Aerial Hunter (bus shelter mural with Native American theme), Municipality of Metropolitan Seattle, Wash.

Glass panels and red cedar panels (representing land, sea and sky themes for the Vancouver International Airport), Vancouver International Airport Authority, Richmond, B.C.

Painted mural (red cedar for feature wall of reception lobby), Ministry of Aboriginal Affairs, Victoria, B.C.

Salmon, Human Faces and Birds (design motifs for the overall design of the Seattle Pump Station), Municipality of Metropolitan Seattle, Wash.

1994 EXHIBITIONS

Exhibition of Northwest Coast Indian Art (selected artists), Nordamerican Indian Museum, Zurich, Switzerland

Point on Granville Island (solo exhibition), New Leaf Editions, Granville Island, Vancouver, B.C.

Zeitgenössische Kunst der Indianer der Nordwestkuste Kanada (selected artists), Bit Im Presseclub, Bonn, Germany

COMMISSIONS

Designs (for the front of the Pacific National Exhibition longhouse), Pacific National Exhibition, Vancouver, B.C.

Dreamspeaker (logo design for DIAND/First Nations newsletter), Department of Indian Affairs Canada, Vancouver, B.C.

Flight (carved red cedar spindle whorl for the International Terminal Building), Vancouver International Airport Authority, Richmond, B.C.

Two logo designs (for the welcome to the 1994 Commonwealth Games), Government of British Columbia, Victoria, B.C.

1995 EXHIBITIONS

Agents of Change: New Views by Northwest Women (selected artists), Seafirst Gallery, Seattle, Wash.

Expressions of Spirit: Contemporary American Indian Art (selected artists), Wheelwright Museum of the American Indian Art, Santa Fe, New Mexico

The Sixth Native American Fine Arts Invitational Exhibition (selected artists), The Heard Museum, Phoenix, Arizona

Women across the Arts (selected artists), Friesen Gallery, Seattle, Wash.

COMMISSIONS

Bone and antler re-creations of historical artifacts (for the exhibition *Written in the Earth: Coast Salish Prehistoric Art*), University of British Columbia Museum of Anthropology, Vancouver, B.C.

Four Salmon (design for the Triangle West Streetscape Medallion Project), City of Vancouver, B.C.

Logo design (for the April 1995 First Nations Summit conference, "Business at the Summit"), Crossroads Consulting Services, Vancouver, B.C.

Pen and ink drawings of Coast Salish artifacts (for the exhibition *Written in the Earth: Coast Salish Prehistoric Art*), University of British Columbia Museum of Anthropology, Vancouver, B.C.

1996 EXHIBITIONS

Remembering the Way: Art of the Native Northwest (selected artists), American Indian Contemporary Arts, San Francisco, Calif.

Susan Point (solo exhibition), Emily Carr House, Victoria, B.C.

COMMISSIONS

Logo design (aboriginal motifs in pastel for an annual aboriginal policy brochure), Placer Dome Canada, Vancouver, B.C.

Logo design, medallions and carved glass plates (for the National Aboriginal Achievement Awards), John Kim-Bell, Canadian Native Arts Foundation, Toronto, Ont.

Salish Woman and *Salish Man* (welcome figures) (carved red cedar house posts for the International Terminal Building), Vancouver International Airport Authority, Richmond, B.C.

Salmon Homecoming (limited edition offset lithographic print of 599 for the Fourth Annual Salmon Homecoming Celebrations), Seattle Aquarium, Wash.

Welcome Figure (red cedar with inlaid copper domes for the University of British Columbia Museum of Anthropology), Royal Bank of Canada, Vancouver, B.C.

1997 EXHIBITIONS

Great Work! An Overview of Contemporary British Columbia Artists (selected artists), atrium of the Hong Kong Bank of Canada, Vancouver, B.C.

Objects of Desire (selected artists), Bay of Spirits Gallery, Toronto, Ont.

River Deep—Mountain High (selected artists; travelling exhibition), St. Fergus Gallery, Wick, Scotland

Topographies: Aspects of Recent British Columbia Art (selected artists; catalogued exhibition), Vancouver Art Gallery, Vancouver, B.C.

Whales: The Enduring Legacy (selected artists), Royal British Columbia Museum, Victoria, B.C.

Written in the Earth (selected artists), University of British Columbia Museum of Anthropology, Vancouver, B.C.

COMMISSIONS

Four Corners (mural for the North Seattle Community College Vocational Education Building), Washington State Arts Commission, Olympia, Wash.

Freedom, Continuing Life Cycle and *Generations* (two architectural glass panels and glass house post for the Sprint Canada Building), Toronto, Ont.

House posts (carved and painted red cedar for the University of British Columbia Museum of Anthropology), Royal Bank of Canada, Vancouver, B.C.

1998 EXHIBITIONS

Ancient Memories through Women's Art (selected artists), Roundhouse Community Centre Gallery, Vancouver, B.C.

Evolving from Tradition (solo exhibition), Richmond Art Gallery, Richmond, B.C.

Fall Antiquities and Art Show (selected artists), Denver Art Museum, Denver, Colo.

Premonitions: Artists Exploring the Possibilities (selected artists; catalogued exhibition), Spirit Wrestler Gallery, Vancouver, B.C.

Redefining Tradition (selected artists), Whatcom Museum of History and Art, Bellingham, Wash.

A Voice to Be Heard (group exhibition), Art Gallery of Greater Victoria, Victoria, B.C.

Walk with Beauty: Contemporary and Traditional Art, Indian Art Northwest Monumental Sculpture Exhibition (selected artists; various locations), downtown Portland, Ore.

COMMISSIONS

Illustration of Inuit children and glass Inukshuk sculpture (commemorative works for Canada's newest territory, Nunavut, to be used in postage stamp and for first-day-of-issue stamp), Canada Post, Ottawa, Ont.

The River—Giver of Life and *Coming Together* (spindle whorl and wall mural for Student Union Building), Langara College, Vancouver, B.C.

Salmon People and *Arrival* (wall sculptures carved from red cedar for the International Terminal Building), Vancouver International Airport Authority, Richmond, B.C.

Red cedar spindle whorl, private collection, Victoria, B.C.

Salmon (glass sculpture), Nortel, Toronto, Ont.

The Whale People (red cedar spindle whorl), Victoria Conference Centre, Victoria, B.C.

1999 EXHIBITIONS

Fusion: Tradition and Discovery (selected artists; catalogued exhibition), Spirit Wrestler Gallery, Vancouver, B.C.

Susan A. Point (solo exhibition), Arctic Raven Gallery, Friday Harbor, Wash.

Susan Point (solo exhibition), Motherland Gallery, Fukuoka, Japan

Vision Keepers: Dale Campbell, Valerie Morgan, Susan A. Point, Isabel Rorick, Alcheringa Gallery, Victoria, B.C.

COMMISSIONS

Salmon (one of five elements on the reverse of the Governor General's Academic Medal), Office of the Governor General of Canada, Ottawa

Written into the Earth (tree grates and bronze medallion for Washington State Football/Soccer Stadium and Exhibition Centre), First and Goal Incorporated, Seattle, Wash.

2000 EXHIBITION

New Art of the West 7 (selected artists), Eiteljorg Museum of American Indians and Western Art, Indianapolis, Ind.

AWARDS

Woman of Distinction Award (Arts and Culture), YWCA, Vancouver, B.C.

Honorary Doctorate in fine arts from the University of Victoria, B.C.

Selected Publications

Arnold, Grant, Monika Kin Gagnon, and Doreen Jensen. 1996. *Topographies: Aspect of Recent British Columbia Art.* Catalogue/Book. Vancouver: Vancouver Art Gallery/Douglas & McIntyre.

Brown, Steven. 1998. *Native Visions: Evolution of Northwest Coast Art from the Eighteenth through the Twentieth Century.* Catalogue/Book. Vancouver and Seattle: Douglas & McIntyre/Seattle Art Museum.

DeMott, Barbara, and Maureen Milburn. 1989. *Beyond Revival: Contemporary North West Native Art.* Catalogue. Vancouver: Charles H. Scott Gallery, Emily Carr College of Art and Design.

Duffek, Karen. 1986. *New Vision.* Museum Note No. 15. Vancouver: Museum of Anthropology, University of British Columbia Press.

Hoffmann, Gerhard. 1988. *Zeitgenösische Kunst der Indianer und Eskimos in Kanada.* Published in conjunction with the exhibition *In the Shadow of the Sun.* Ottawa: Canadian Museum of Civilization.

Monds, Elaine. 1994. *Life of the Copper: A Commonwealth of Tribal Nations.* Catalogue. Victoria: Alcheringa Gallery.

Spirit Wrestler Gallery. 1998. *Premonitions: Artists Exploring the Possibilities.* Catalogue. Vancouver: Spirit Wrestler Gallery.

—. 1999. *Fusion: Tradition and Discovery.* Catalogue. Vancouver: Spirit Wrestler Gallery.

Thunder Bay Art Gallery. 1989. *From Periphery to Centre: The Art of Susan and Krista Point.* Catalogue. Thunder Bay, Ont.: Thunder Bay Art Gallery.

University of British Columbia Museum of Anthropology. 1999. *Objects and Expressions: Celebrating the Collections of the Museum of Anthropology at the University of British Columbia.* Various Authors. Vancouver: University of British Columbia Museum of Anthropology.

Wyatt, Gary. 1999. *Mythic Beings: Spirit Art of the Northwest Coast.* Vancouver and Seattle: Douglas & McIntyre/University of Washington Press.